IMAGES
of America

DELAWARE *in the* GREAT DEPRESSION

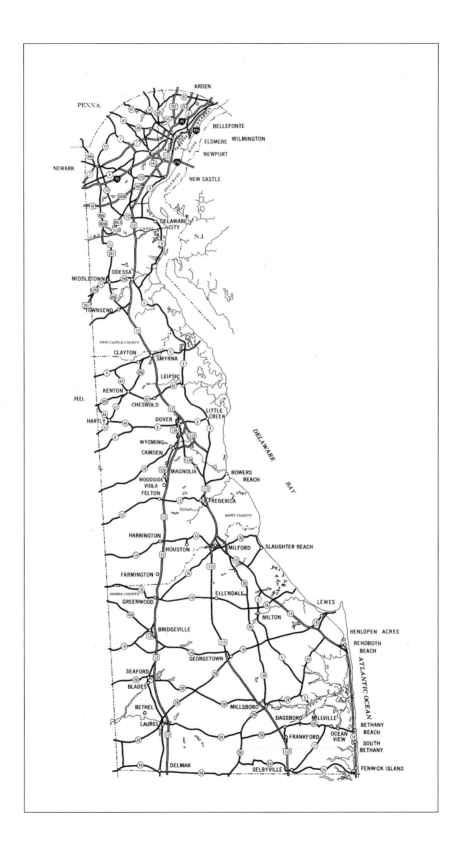

IMAGES
of America

DELAWARE *in the*
GREAT DEPRESSION

R. Brian Page

ARCADIA

Published by Arcadia Publishing
Charleston SC, Chicago IL, Portsmouth NH, San Francisco CA

Printed in Great Britain

Library of Congress Catalog Card Number: 2005920054

For all general information contact Arcadia Publishing at:
Telephone 843-853-2070
Fax 843-853-0044
E-mail sales@arcadiapublishing.com
For customer service and orders:
Toll-Free 1-888-313-2665

Visit us on the internet at http://www.arcadiapublishing.com

For my father and grandfather

CONTENTS

Acknowledgments 6

Introduction 7

1. Government 11

2. Business and Industry 23

3. Agrarian Life 37

4. City Life 51

5. Baseball and Recreation 69

6. The Civilian Conservation Corps: "We Can Take It!" 83

7. Preparing for World War II 111

8. Appendix I: The CCC and the Development of Forestry
 During the Great Depression 121

ACKNOWLEDGMENTS

No single book can capture the spirit of an age. Instead, the best any historian can do is try to weave a historical narrative that offers a panoramic view of the breadth of activity that occurred, and offer readers in the present a sense of what it was like in the past. This book seeks to do that. Written records of the Great Depression in Delaware are copious and largely unstudied, and I would not have been able to interpret or understand them in context without the critical eye of too many people to mention. It is for them that this book is written. Any imperfections in my understanding of this important period are my own.

No book is ever written alone. It takes the contribution, criticism, and assistance of many people to produce even a small volume such as this one. It is not possible to thank all the people who helped me write this book, but I would like to point out the following: the extraordinary assistance of Ellen Rendell at the Historical Society of Delaware; Timothy A. Slavin, the director of the Delaware Public Archives, and his staff, in particular Lori Hatch, Dawn Mitchell, Randy Goss, and Russell McCabe; Dan Griffith and Joan Larrivee, Robin Bodo, and Alice Guerrant, who have helped me in ways too numerous to mention; and finally, Robert Stickels, Michael Izzo, Russ Archut, Douglass Stewart, Brad Hawkes, Jayne Ellen Dickerson, and all the staff at the Sussex County Engineering Department.

I am particularly indebted to the scholarship of other historians, especially David G. Orr, David Ames, Rebecca Sheppard, Bernard Herman, and the staff and students at the University of Delaware Center for Historic Architecture and Design, whose work and perceptive eyes have influenced my work; I owe a tremendous debt to William Williams, Carol Hoffecker, and Donald Kagan, whose guidance, support, and understanding of American history and classical civilization continues to inform and enrich my work.

Some of the photos in this book are exceedingly rare, so it was not always possible to maintain the absolute highest quality without sacrificing the substance of these photographs.

INTRODUCTION

The Great Depression transformed the politics, economics, and agriculture of Delaware more than any single event in the history of the state. This crucible of poverty, hardship, and material want became the fertile ground for innovations in agriculture, chicken breeding, the development of nylon, new chemical compounds, and industrial techniques that would, in the course of time, change the way people around the world live. How is it that this tiny state on the edge of swamps and marshes would unleash its human potential and transform itself from a parochial backwater into a modern industrial and agricultural behemoth in little over a decade?

In a very modest way, this book attempts to answer that question, not with words, but through photographs.

This question always fascinated my grandfather. A Delaware native, he grew up on a farm on Newport Gap Pike. He was born at the height of the 1918 flu epidemic; lived through the greatest financial turmoil in recorded history; grew to manhood during our bitter struggle against Nazi Germany, Fascist Italy, and Imperial Japan; finally married; and had children with the coming of peace. His experience is not unique; so many people of his generation lived through these conflicts and struggles that we call them collectively the "Greatest Generation."

In Delaware, this decade also saw the rise and development of the modern political discourse, which still shapes the policy of the state. The radical mixture of antipathy and symbiosis between an industrial Wilmington and an agrarian Delmarva, the conflict between excessive wealth and crushing poverty, the role of government and the free market, and the division between liberal and conservative politics made a lasting impression that continues to inform the political process of the state. The contradictions, my grandfather used to say, left Delaware as the only state that grew "liberal Republicans and conservative Democrats as fast as they grow chickens."

Nevertheless, to this day, the Great Depression is one of the least explored historical subjects in the encomium of the state's recent past. Even the most respected historians of the state only touch on it as a cursory note in their larger and more comprehensive bodies of work—choosing instead to focus on the settlement, population dynamics, slavery, and the commencement of industry that set the tone of much of the state's history. It is not uncommon to see statistics from the Depression used to show how well industry developed in Wilmington under the DuPonts, or how strong the opposition to racial reform was, but it is rare to hear them set in the larger context of the Depression. My grandfather always thought it was unfortunate that World War II and the development of aviation received more attention then the impact of the

Great Depression in Delaware. And to his credit, it would be impossible to assess the importance of these events or put them into a historical context without understanding the impact that the Great Depression had on the state.

Why is it that in little over a decade, from 1929 to 1941, almost all of the state's early achievements in infrastructure—from the completion and expansion of the DuPont Highway in 1933 and the development of paved roads in lower Delaware to St. George's Bridge in New Castle—and that all of the problems, polemics, and questions that shape the state's modern history were framed? It could be that the gentle philanthropy of Alfred I. DuPont—who lobbied the state legislature for a pension system and, when confronted with rejection by the state legislature, wrote checks to the elderly and disabled of the state from his personal account—is too close to home to address through the lens of historical empiricism. It could also be the fact that over 11,000 workers, mostly in Wilmington, were chronically unemployed for over a decade—or that every single family in the state had to sacrifice something to maintain the balance between agriculture and industry—that was difficult enough to live through, let alone expose to historical exegesis.

While across the sea Imperial Japan and Germany waged an aggressive, unprovoked war that killed millions in Europe, Korea, and China, Delawareans were quietly and humbly laying the material groundwork for the modern world. We may never know if Celia Steele and her husband Wilbur realized the impact that their new, meatier Delmarva broiler chickens would have on the world or if they simply wanted to make extra money by selling their birds at farmers' markets across Delmarva, but we do know how successful she was at breeding, production, and marketing, literally selling tens of thousands of birds in her first few years of operation.

In 1928, Herbert Hoover's campaign team proudly spread the idea that a chicken in every pot was the right of every American, yet, by 1930, very few would deny that his administration brought on the worst financial tragedy in two centuries of American history. At the same time, Celia Steele, a housewife from Ocean View, Delaware, made affordable poultry a reality. In 1932, when Franklin Roosevelt announced that in the modern age "we need new materials to build a new world," it was Wallace Hume Carothers at the DuPont Company who developed neoprene and rayon before finally developing nylon on May 24, 1934, and whose seminal work in chemical engineering contributed to the development of plastic.

The importance of these two events in the history and development of the nation after World War II, and the rise of new agricultural and industrial techniques that these events inaugurated, cannot be underestimated. In a little less then 100 years, Celia Steele's chickens would be as accessible in Bangkok, Thailand, as they were in Delaware, and virtually the whole modern clothing industry owes its existence to Carother's development of nylon. What is even more remarkable is that both events took place less than 100 miles from each other, in the same state, during the height of the worst financial crisis in United States history!

This represented a radically expansive and fundamentally different role than Delaware had ever played in the larger context of United States history. These two success stories mark the beginning of a transformation in the way Delawareans thought about their tiny state and its potential. The effect of this transformation far outweighed the relatively small size of the population of 238,380 in 1930. That a little under a quarter of a million people could accomplish changes this momentous seemed to prove that Delaware was no longer just a simple backwater of industry with deeply rooted farming traditions. Rather, after World War I, it was an industrial powerhouse whose inventions would fuel a revolution in chemistry that culminated in the development of plastic. No longer was it an agrarian lightweight compared to the fertile soil and rich animal husbandry of Maryland, Virginia, and the South. Instead, it was ground zero of the world's first and most successful poultry industry.

Without the impetus of financial hardship that the Great Depression provided and a resounding belief that necessity is truly the mother of invention and that better days were ahead—coupled with the encouragement and philanthropy of Delaware's elite—it is impossible to understand how Delaware made it through one of the most contentious periods of American

history in a stronger, more flexible position, ready to adapt to the challenges of both World War II and the explosive population growth that followed the war. In short, almost alone among the states, Delaware was not found wanting when it finally emerged from a little over a decade of financial turmoil.

This alone is a remarkable testament to the resilience, courage, and the deep intellectual, spiritual, and material resources that Delawareans had to draw on to face tragedy, poverty, and hardship. If these were the only accomplishments of the period it would be remarkable enough, but they were not. In addition to these developments in agriculture and industry, the Civilian Conservation Corps (CCC) drained the swamps of the state, created the first parks, surveyed the biological diversity of the state, and, with the assistance of Coleman DuPont, created the first state forest. They built sand dunes at our beaches and reclaimed land in the state from Lewes to Fenwick Island. DuPont Highway was finished to extend from markets in Philadelphia to manufacturers in Virginia. P.S. DuPont's philanthropy revolutionized the school system of the state, and between 1920 and 1935, almost every school was upgraded, rebuilt, and transformed. As a result, between 1926 and 1934, Delaware schools rose from being ranked 43rd in the nation to 10th.

Douglass Buck's election in 1929 made Delaware one of only two states to elect a Republican governor to office that year, and following his re-election in 1932, Delaware was the only state with a Republican governor during the worst years of the Depression. From January 16, 1933, until the expiration of his second term in 1937, Governor Buck proved himself an able administrator capable of handling the challenges of the Depression in unique ways. As early as 1933, he had dissolved the legislature, then restored it, cut the salary of state workers in half, and started a search for innovative ways to run a government on a shoestring budget. With the assistance of John Townsend and Delaware's federal congressional representation, Delaware had no bank closures. This is all the more remarkable if you consider that during the first three years of the Depression, over 2,500 banks failed across the country—over 342 in February 1931 alone.

For the average person in Delaware, the Depression marked a time of bitter insecurity and resentment for both the poor, who were thought to be demanding too much, and the rich, whose charity was looked upon with ambivalence. Many among the middle class were one medical emergency away from financial crisis and poverty. Many were simply too poor to realize they were no longer part of the middle class. The small farmers in Kent and Sussex Counties fared little better, and there was a cloud of constant fear that banks would call in mortgages and repossess farms in Delaware just as they were doing in the Midwest. This fear did not end until the beginning of World War II in December 1941.

Segregation, racism, and underlying bigotry continued to plague African Americans across the state. Starting in 1919, P.S. DuPont rebuilt all the African-American schools in the state, and with new schools, a new hope and optimism was born that education would lead to freedom. This is reflected in Alice Dunbar Nelson's eloquent work and the reforms of the Citizen's Service Commission.

For the young wage earner in Wilmington, hope lay in joining the Works Progress Administration (WPA) or the CCC. If workers did not meet the age requirements for either of these services, there was always work to be found around the docks, where Delaware's longshoremen vacillated between sharing work and jealously guarding their union guarantees; and when the docks were either unable or unwilling to accept extra labor, men could find work with the mayor of Wilmington's Relief Committee. The Wilmington Relief Committee immediately set out to rebuild the roads, upgrade them, and produce the first paved roads in some areas of northern New Castle County as well as various overlooked parts of Wilmington, including portions of the swampy east side of the city. While the CCC built roads and parks and helped establish the forests of the state, unfortunately, their work in mosquito control ushered in an unprecedented use of DDT, while at the same time their trenches left an irrevocable pattern on the landscape of the state.

Artistry was encouraged and supported by the WPA, which sought out artists like Jack Lewis and writers like Janette Eckman and directed the work of the Historic American Building Survey.

Baseball finally came into its own. Almost every Delaware town had its own minor league team. In Port Penn, the team was called the Peaches after the peach cannery in town. Steamboats ferried Wilmingtonians to Augustine Beach and Port Penn for weekend picnics. Towns like Bay View, Odessa, and Elsmere all fielded teams, while players viciously competed for a prized spot in the big leagues. In traveling from his home in Marshallton, William "Judy" Johnson, the great African-American ballplayer in the Negro leagues, opened up new avenues for professional black athletes.

The Great Depression in Delaware was a time of unparalleled struggle to maintain the integrity of the state and its people and to make use of the state's natural and human resources. It was during the unprecedented coming of World War II and its aftermath that Delaware finally saw the fulfillment of the work inaugurated during the Depression.

The pictures in this book represent Delawareans, their landmarks, their struggles, and their life during this crucial period in the state's history. It attempts to explain how these things transformed the state and how that transformation changed our society. Hopefully you come away from this small and necessarily incomplete study with a greater appreciation of the effect the Great Depression had on Delaware as well as an appreciation of the people who lived through it.

Brian Page
Georgetown, Delaware
January 21, 2005

One

GOVERNMENT

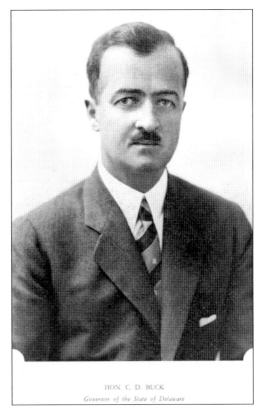

**DOUGLASS C. BUCK, DELAWARE'S
GOVERNOR FROM 1929 TO 1937.**
Governor Buck was an engineer from
New Castle County who had worked briefly
with Coleman DuPont on the construction
of the DuPont Highway, but whose real
talent lay in administration. In 1933, when
legislators from New Castle, Kent, and
Sussex could not agree on state
disbursements, he temporarily dissolved the
legislature to illustrate the dramatic
problems the state faced. (Courtesy of the
Delaware State Archives.)

HON. C. D. BUCK
Governor of the State of Delaware

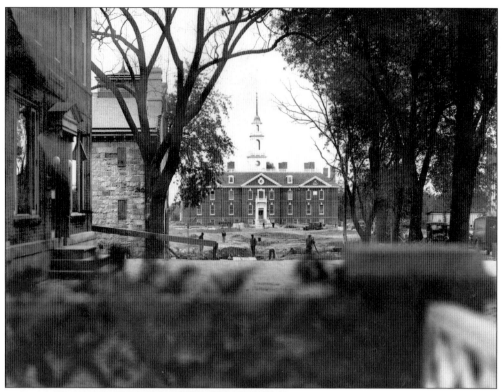

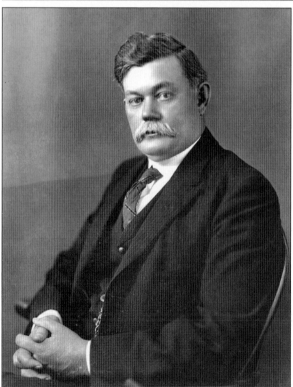

LEGISLATIVE HALL IN DOVER, DELAWARE. The State Buildings and Grounds Commission directed construction of the building after 1931. It opened two years later in 1933. (Courtesy of the Delaware Public Archives.)

JOHN GILLIS TOWNSEND. Townsend was one of Delaware's two Republican senators during the Great Depression. He also served as the governor of Delaware from 1917 until 1921. During the Depression, with the assistance of Rep. Robert Griffith Houston and Sen. Daniel Oren Hastings, he worked to prevent Delaware from having any bank closures. He remained Delaware's senator throughout the Depression until 1941. From 1939 until 1940, he served on the Mount Rushmore Committee in the Senate. (Courtesy of the Delaware Public Archives.)

ROBERT GRIFFITH HOUSTON. Houston was the New Castle County congressman who helped draft the 1921 school law and supported the work of John G. Townsend during the Great Depression. After 1933, he resumed the practice of law in Georgetown, Delaware, until his death in 1946. (Courtesy of the Delaware Public Archives.)

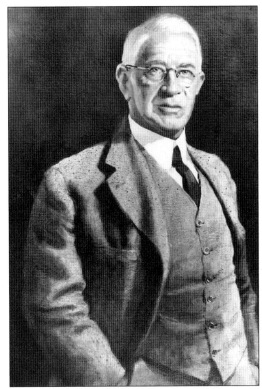

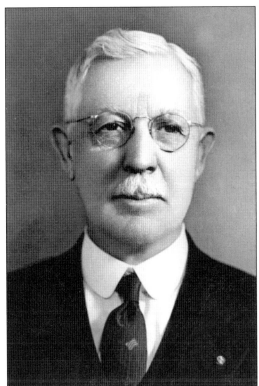

GOV. RICHARD C. McMULLEN. Elected governor of Delaware in November 1936, Governor McMullen was the first of a number of Democrats elected to political office that year. He served from 1937 until 1941. (Courtesy of the Delaware Public Archives.)

ALFRED I. DuPONT. Dupont was the enigmatic leader of the state's most prestigious family, whose philanthropy provided the stimulus for continued development in Delaware during the Depression and whose company created the "better living through chemistry" campaign so popular in the 1940s. (Courtesy of the Delaware State Archives.)

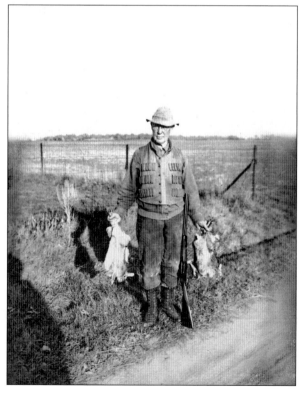

GOVERNOR McMULLEN, FIRST DAY OF HUNTING SEASON, 1939. Governor McMullen was an avid hunter as well as an exceptional statesman. He was the 49th governor of the state. (Courtesy of the Delaware Public Archives.)

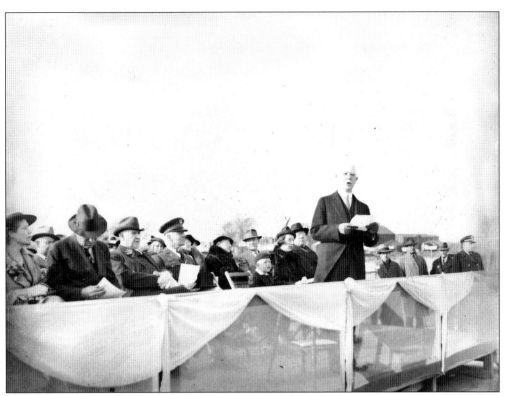

GOVERNOR MCMULLEN. McMullen is pictured here giving the introductory remarks at Delaware's Swedish Tercentenary in 1938 to commemorate the founding of Fort Christina in Wilmington. The event was so important that both the king of Sweden and President Franklin Roosevelt attended. (Courtesy of the Delaware Public Archives.)

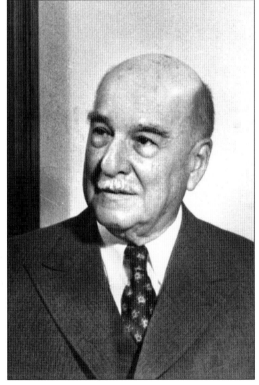

P.S. DUPONT. After funding the establishment of the Service Citizens Organization in 1919, P.S. DuPont started a 30-year political campaign to improve education in Delaware. From 1919 through the middle of the Depression, DuPont funded the construction of new schools for the state of Delaware. (Courtesy of the Delaware Public Archives.)

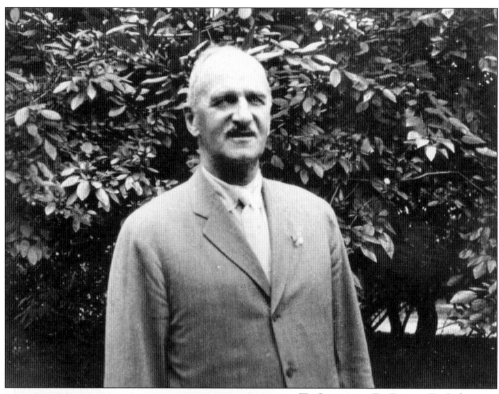

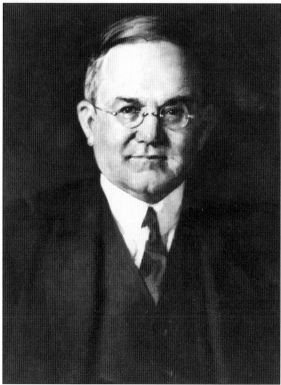

T. Coleman DuPont. T. Coleman DuPont was the founder of the conservation movement in Delaware and funded the construction of the DuPont Highway. Though a two-lane highway was finished in 1924, it soon proved insufficient, and DuPont, through lobbying the State Highway Department, had it expanded starting in 1932. (Courtesy of the Delaware Public Archives.)

Daniel Oren Hastings. The New Castle County Republican was elected to the Senate after the resignation of T. Coleman DuPont in 1931. He served in the Senate until 1937. During the Depression, Delaware was one of the only states to elect Republicans to every major political office in the state. (Courtesy of the Delaware Public Archives.)

MR. HENRY B. THOMPSON AND MRS. MARY WILSON THOMPSON, c. 1928. Mary Wilson Thompson was extremely politically active throughout the Great Depression. During the 1920s, she led the anti-suffragette movement in Delaware, and starting in 1933 she petitioned Governor Buck to start the CCC in the state. (Courtesy of the Delaware Public Archives.)

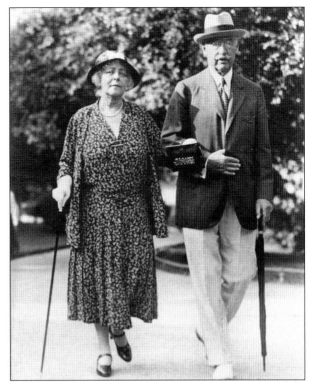

JAMES HARRISON WILSON THOMPSON, BROOKWOOD FARM, 1936. Jim Thompson was a Princeton graduate and the son of Mary Wilson Thompson. During the 1930s, Thompson worked with his mother in Delaware politics. At the start of World War II, he joined the OSS, the precursor to the CIA, and after the war he purchased the Thai Silk Company and helped rebuild Thailand's national economy. (Courtesy of the Delaware Public Archives.)

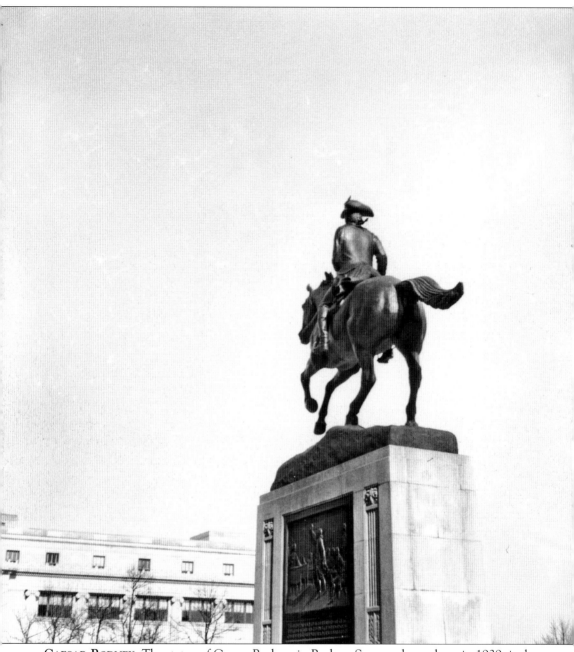

CAESAR RODNEY. The statue of Caesar Rodney in Rodney Square, shown here in 1939, is the symbolic center of Wilmington. (Courtesy of the Historical Society of Delaware.)

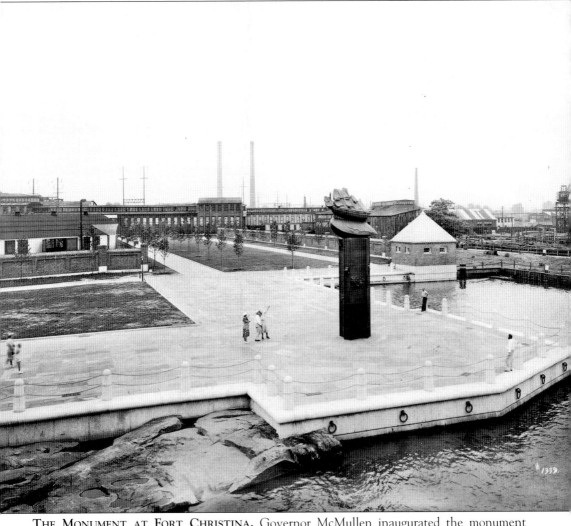

THE MONUMENT AT FORT CHRISTINA. Governor McMullen inaugurated the monument at the rocks at the site of Fort Christina in 1938. The park was part of Delaware's 1938 celebration of the tercentennial landing of the Swedes in Wilmington. (Courtesy of the Delaware Public Archives.)

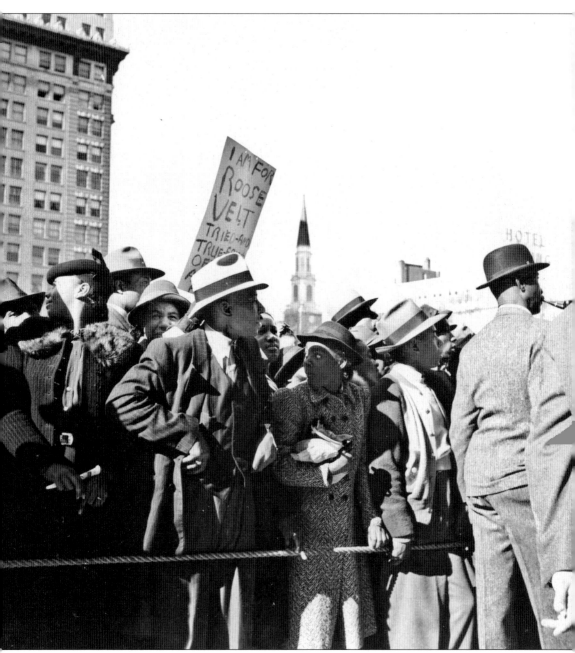

WENDELL WILKIE CAMPAIGN RALLY, 1940. "I am for Roosevelt, Tried and True," reads the sign of a partisan at the October 31, 1940 political rally for Republican presidential nominee Wendell Wilkie. "Move over Eleanor, the Wilkie's are coming," read the campaign buttons given out at the rally. (Courtesy of the Historical Society of Delaware.)

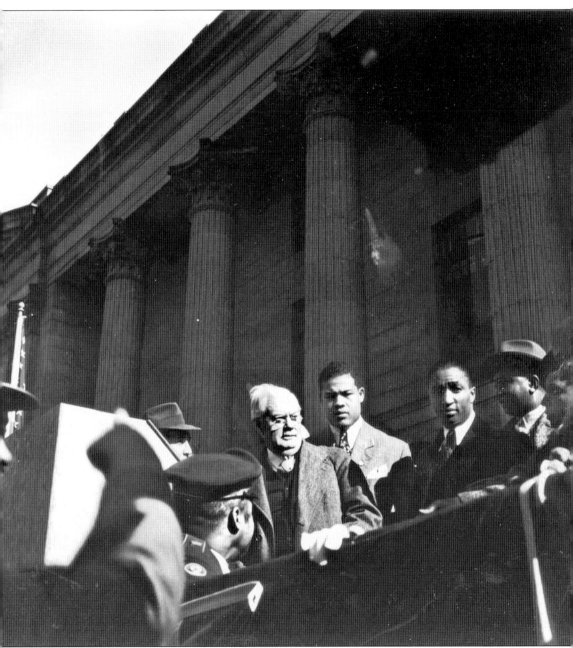

WENDELL WILKIE AND JOE LOUIS, "THE BROWN BOMBER," OCTOBER 31, 1940. After his historic victory over the German boxer Maximillian Schmeling on June 22, 1938, Joe Louis was the most famous boxer in the nation. In the ideologically significant bout, Joe, cast as the defender of American ideals, knocked the Nazi world champion Max Schmeling out in the first round. It was the "shot that knocked the Axis off balance." Here Joe Louis poses outside the Wilmington Courthouse. Wendell Wilkie was the Republican candidate for president in 1940 who lost to Franklin Delano Roosevelt. (Courtesy of the Historical Society of Delaware.)

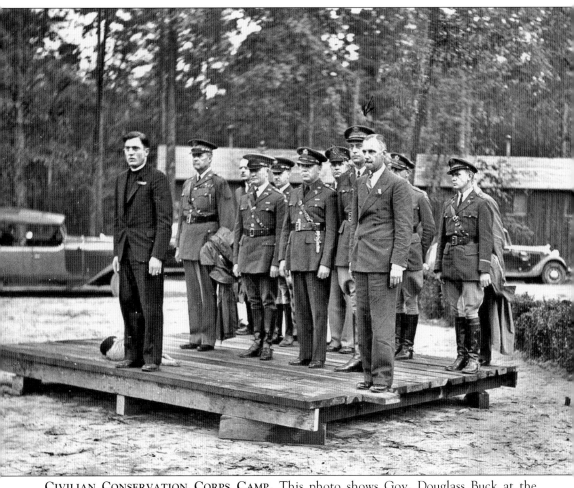

CIVILIAN CONSERVATION CORPS CAMP. This photo shows Gov. Douglass Buck at the newly constructed CCC camp at Redden State Forest, *c.* 1934. (Courtesy of the Delaware Public Archives.)

Two
BUSINESS AND INDUSTRY

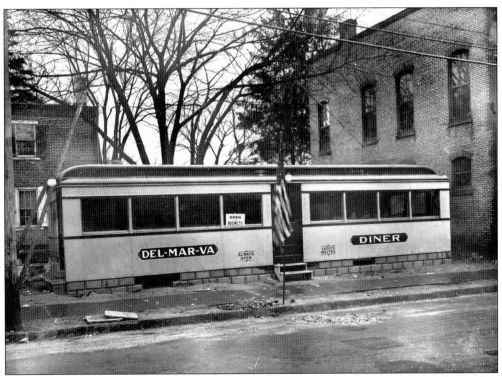

THE DELMARVA DINING CAR, JANUARY 15, 1929. The Delmarva Dining Car, located in Middletown, was representative of an average small business in Delaware during the time. Much like Zenbie's Diner in New Castle and other roadside restaurants, this diner was built for automobile traffic across the state. (Courtesy of the Delaware Public Archives.)

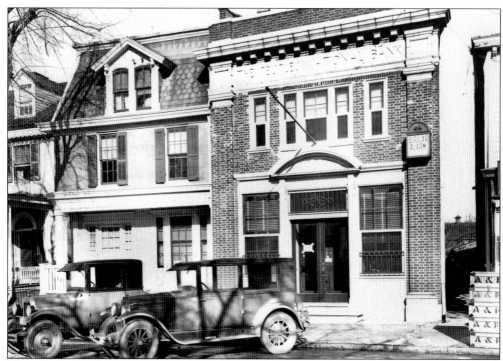

PEOPLE'S NATIONAL BANK, JANUARY 19, 1929. This bank in Middletown was typical of the small rural banks that made up much of Delaware's banking industry during the early 20th century. (Courtesy of the Delaware Public Archives.)

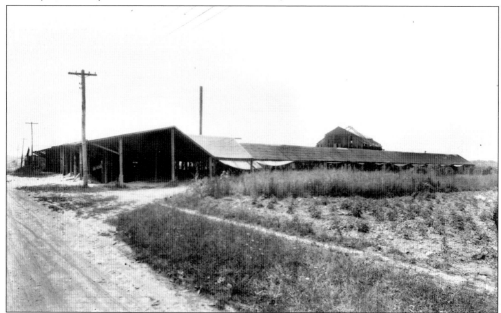

AUGUST 9, 1929, DOVER BRICK FACTORY. Brick factories like this one in Dover were important in supplying contractors in lower Delaware during the late 1920s and through the Depression. This photo illustrates the grueling manual labor that brick workers were subject to throughout the period. (Courtesy of the Delaware Public Archives.)

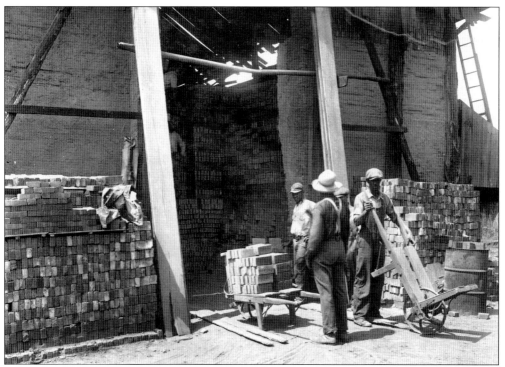

AUGUST 8, 1929, "BRICKS READY FOR BURNING." This scene illustrates the Dover Brick works with workmen outside. Throughout the Great Depression, African Americans were the predominate source of manual labor for farm work and in unskilled construction. (Courtesy of the Delaware Public Archives.)

CORK INSULATION CORPORATION, WILMINGTON, DELAWARE, FEBRUARY 9, 1932. Cork was the predominate type of insulation at the time and was used throughout 1930s for laying carpets and for putting beneath new flooring. (Courtesy of the Delaware Public Archives.)

TANNIN CORPORATION, WILMINGTON, DELAWARE, FEBRUARY 9, 1932. One of the major leather production facilities in the state, the Tannin Corporation was located at the Wilmington Marine Terminal. (Courtesy of the Delaware Public Archives.)

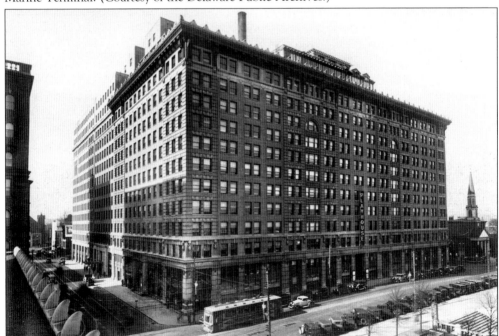

DUPONT COMPANY OFFICES IN WILMINGTON, DELAWARE, 1932. The Dupont Building is a Wilmington landmark. From this building, the DuPonts managed the largest and most significant chemical company in the state. It was at their regional laboratory in 1934 that Wallace Hume Carothers invented nylon. (Courtesy of the Delaware Public Archives.)

THE DUPONT BUILDING AND THE CLASSICALLY INSPIRED WILMINGTON PUBLIC LIBRARY. These buildings, on the south edge of Rodney Square, are masterpieces of juxtaposing the old and new in the city. They are seen here in 1939. (Courtesy of the Historical Society of Delaware.)

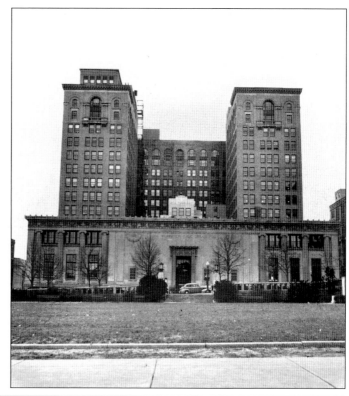

A.S. WOLLEY COMPANY, DELAWARE, MAY 2, 1935. A.S Wolley and Sons was one of the largest and most significant fertilizer companies along the Nanticoke River. (Courtesy of the Delaware Public Archives.)

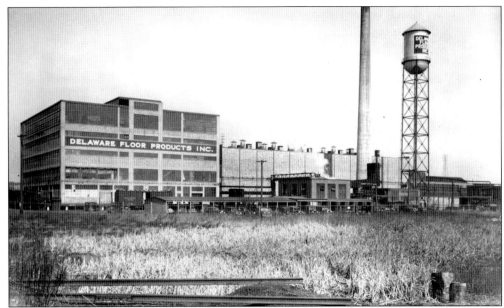

DELAWARE FLOOR PRODUCTS, WILMINGTON MARINE TERMINAL, FEBRUARY 28, 1936. The export of lumber from Sussex County and Maryland to Wilmington was primarily a maritime trade. This picture illustrates the overwhelming reliance on domestic waterways for transportation during the 1930s. (Courtesy of the Delaware Public Archives.)

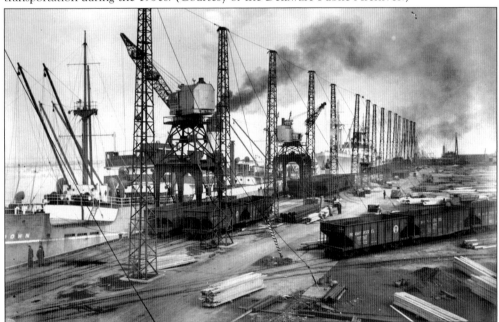

WILMINGTON MARINE TERMINAL, MARCH 4, 1936. The Wilmington Marine Terminal was the most important maritime access point in the state. Companies such as Pusey and Jones Shipyard and Harlan and Hollingsworth were located along the Christine River just north of the terminal. This photo illustrates the steamers *Harbelsdown* and *Tonsbery Fjord* at the marine terminal. Designed for commercial traffic, the Wilmington Marine Terminal is the maritime commercial center of the state. (Courtesy of the Delaware Public Archives.)

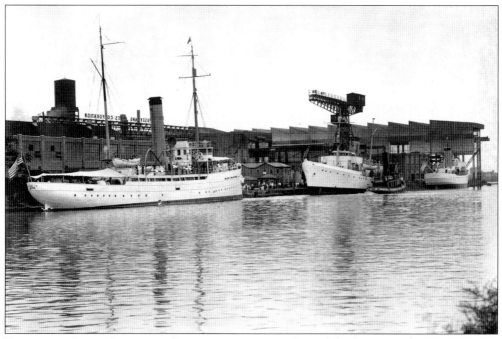

PUSEY AND JONES SHIPYARD, SEPTEMBER 6, 1934. One of the largest and most important shipyards in the country during the 19th century, Pusey and Jones manufactured distinctive ships for a diverse clientele. (Courtesy of the Delaware Public Archives.)

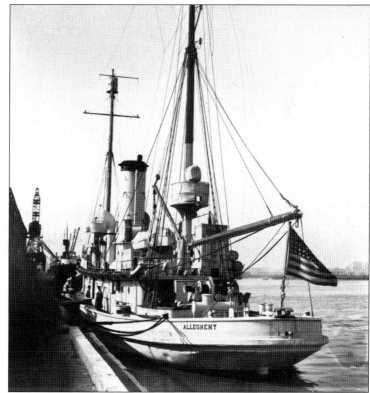

USS ALLEGHENY. The USS *Allegheny*, docked at the Wilmington Marine Terminal on February 21, 1939, illustrates Wilmington's reliance on marine traffic and commerce. (Courtesy of the Historical Society of Delaware.)

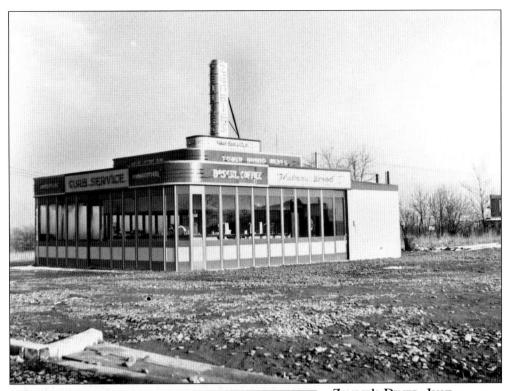

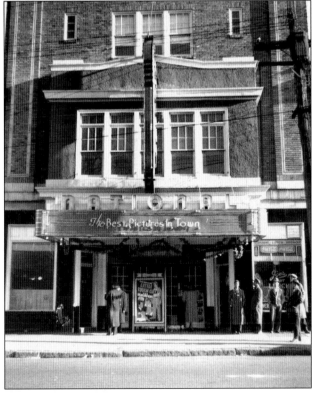

ZENBIE'S DINER, JUST OUTSIDE OF WILMINGTON, DELAWARE, FEBRUARY 2, 1939. The roadside diner was a creation of the automobile. Zenbie's represents the type of roadside fast food that is ubiquitous today, but in the 1930s, it represented a dramatic shift in eating habits and locations. (Courtesy of the Historical Society of Delaware.)

THE NATIONAL THEATER IN WILMINGTON. The National Theater, seen here on December 4, 1938, was a Wilmington landmark and was one of the first theaters in the city. During the Depression, the theaters in Wilmington were a popular form of entertainment as well as part of the larger entertainment industry. (Courtesy of the Historical Society of Delaware.)

JOHN O. HOPKINS.
Hopkins, seen here on
December 4, 1938, was
manager of the
National Theater in
Wilmington. (Courtesy
of the Historical
Society of Delaware.)

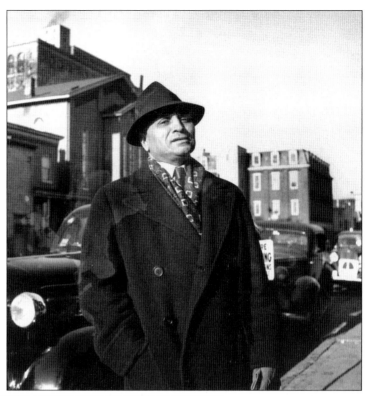

**THE FAMILY OWNERS
OF THE SUNOCO
GAS STATION,
WILMINGTON.** The
family stands here
near their car.
Increasing car
ownership during the
1930s and 1940s
eventually led to the
development of
numerous gas stations
throughout the city.
(Courtesy of the
Historical Society
of Delaware.)

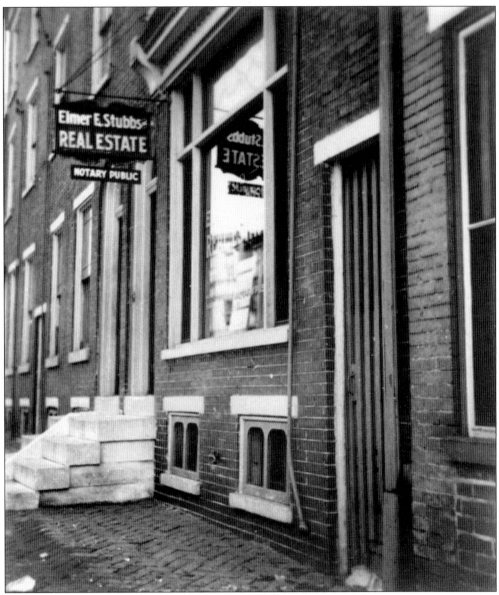

ELMER E. STUBBS REAL ESTATE, JANUARY 21, 1939. An African-American–owned business on the east side of Wilmington was a rare thing before the 1900s. (Courtesy of the Historical Society of Delaware.)

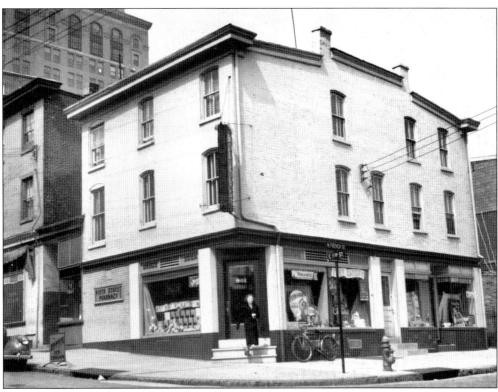

NINTH STREET PHARMACY, JUNE 1939. This was one of the first black-owned pharmacies in the state. (Courtesy of the Historical Society of Delaware.)

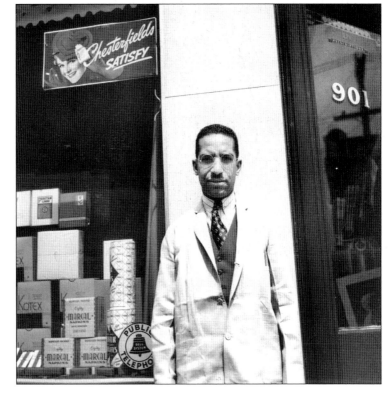

DR. JOHN D. DAVIDSON, THE OWNER OF THE NINTH STREET PHARMACY. John Davidson is shown here on June 1939. (Courtesy of the Historical Society of Delaware.)

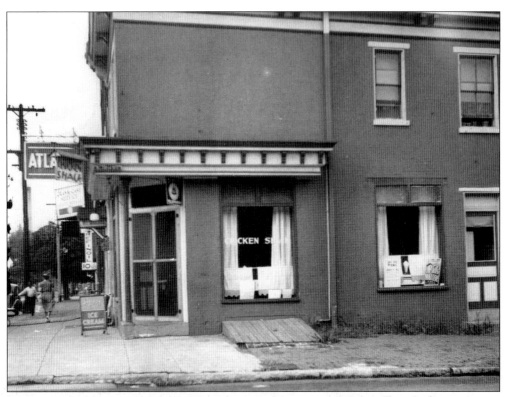

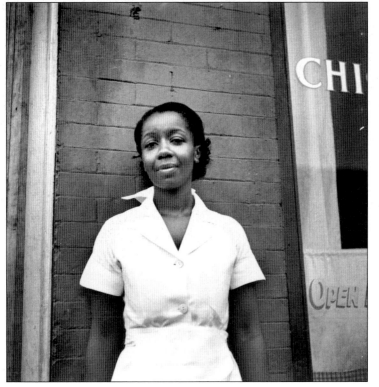

ELSIE'S CHICKEN
SHACK ON THE
EAST SIDE OF
WILMINGTON, C.
1940. During the
late 1930s, it was
becoming less rare to
see African-American
women who owned
small businesses in
the city. (Courtesy of
the Historical Society
of Delaware.)

MS. ELSIE, OWNER
OF ELSIE'S CHICKEN
SHACK. Ms. Elsie is
shown here, c. 1940.
(Courtesy of the
Historical Society
of Delaware.)

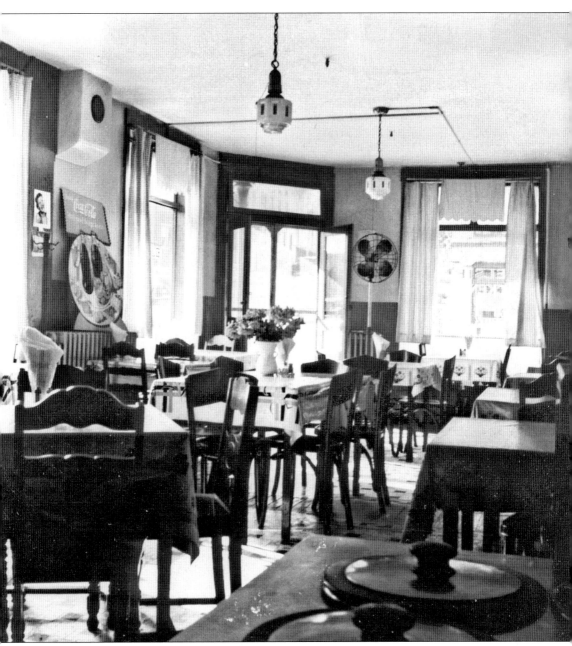

INTERIOR VIEW OF ELSIE'S CHICKEN SHACK, C. 1940. This rare interior view illustrates the care Elsie took to make her restaurant a nice place to eat despite her relatively humble means. (Courtesy of the Historical Society of Delaware.)

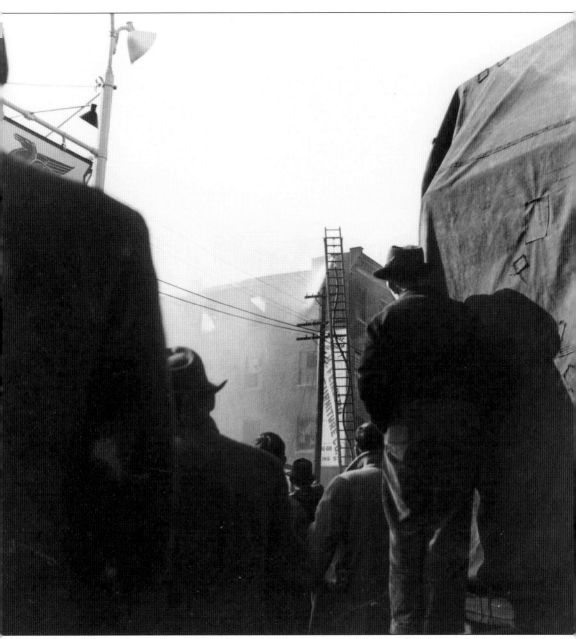

FIRE AT THE H. FIENBURG FURNITURE COMPANY IN DOWNTOWN WILMINGTON, 1940.
During the late 1930s and early 1940s, fires were a common threat to Wilmington businesses.
Electricity supply was not regulated and wires were not always properly grounded, which often
led to fire. (Courtesy of the Historical Society of Delaware.)

Three

AGRARIAN LIFE

LIMA BEAN SHELLER NEAR MILTON, OCTOBER 10, 1935. Agriculture in Delaware until modern times consisted of diversified plantings, and family farmers started using tractors and new equipment to ease the transition to a mechanized farm economy. (Courtesy of the Delaware Public Archives.)

O.A. DOREST FARMS, A STRAWBERRY FARM OUTSIDE OF BRIDGEVILLE, SEPTEMBER 27, 1934. Throughout the 19th century and during the first decades of the 20th century, strawberries, blueberries, and blackberries were regularly grown to supplement more traditional truck-crop incomes in lower Delaware. Strawberries were the most popular. (Courtesy of the Delaware Public Archives.)

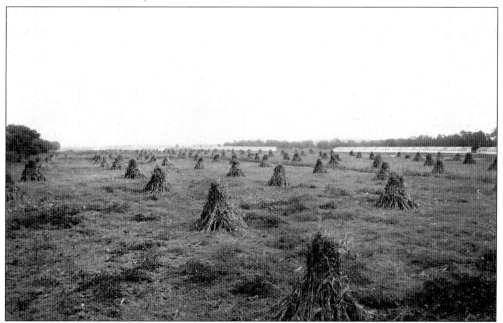

"STEELE'S PLANT," OCEAN VIEW, DELAWARE, OCTOBER 13, 1936. Celia and Wilbur Steele's farming techniques revolutionized chicken farming and started a poultry-growing revolution by the mid- to late-1930s; she started selling the meatier broiler chickens to markets in Philadelphia and New York. (Courtesy of the Delaware Public Archives.)

THE STEELE FARM—CELIA STEELE AND AN ASSISTANT VACCINATE A CHICKEN ON OCTOBER 13, 1968. In February 1923, Celia was expecting a delivery of 50 chickens. She intended to start a modest coup and collect the eggs. Instead, over 500 chickens arrived. After raising them, she was able to sell them to restaurateurs in New York and Philadelphia for the ridiculously low price of 62¢ per pound. (Courtesy of the Delaware Public Archives.)

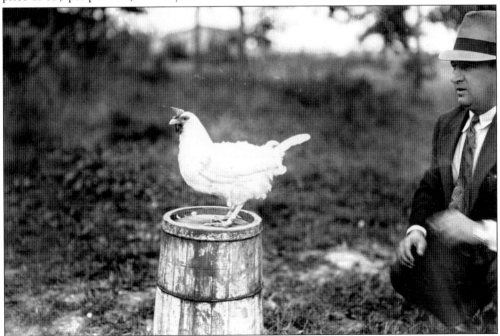

A WHITE LEGHORN CHICKEN AT THE R.D. BOYCE FARM IN SEAFORD, DELAWARE, OCTOBER 13, 1936. The white broiler chicken and its derivatives are the most common type of chicken in use today, and most of the faster-growing breeds were pioneered on Delmarva during the late 1930s. (Courtesy of the Delaware State Archives.)

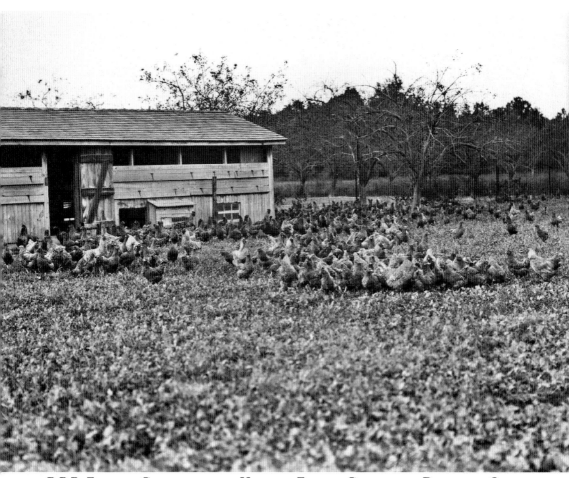

B.P.R. FLOCK OF CHICKENS AT THE HATFIELD FARM IN GREENWOOD, DELAWARE, OCTOBER 13, 1936. As the poultry industry started to grow, techniques for growing chickens became more sophisticated, chicken houses began to take on more uniform shapes, and the chickens were much larger, reached maturity faster, and could be harvested with greater regularity. (Courtesy of the Delaware State Archives.)

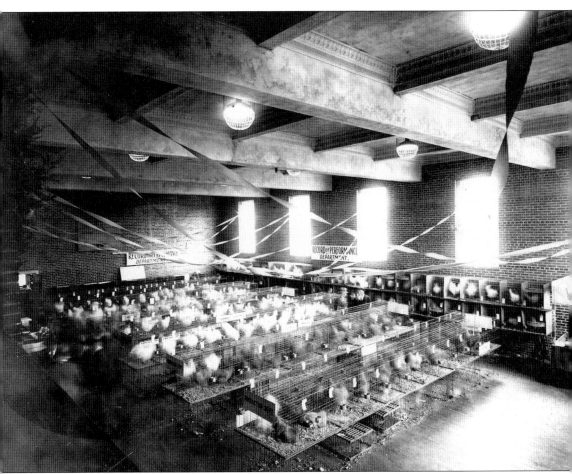

THE MILFORD POULTRY SHOW, MILFORD, DELAWARE, C. 1937. The poultry industry in Delaware started in Ocean View and quickly became the most profitable and sustainable source of income for farmers during the Great Depression. This picture captures the beginning of a revolution in poultry breeding and marketing. (Courtesy of the Delaware Public Archives.)

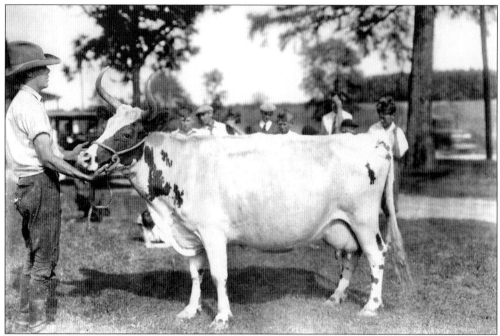

A Farmer with his Dairy Cow at the Delaware State Fair, Harrington, Delaware, June 16, 1931. Dairy production in Delaware was self-sustaining through the 1930s until the dramatic rise in the profitability of poultry. (Courtesy of the Delaware Public Archives.)

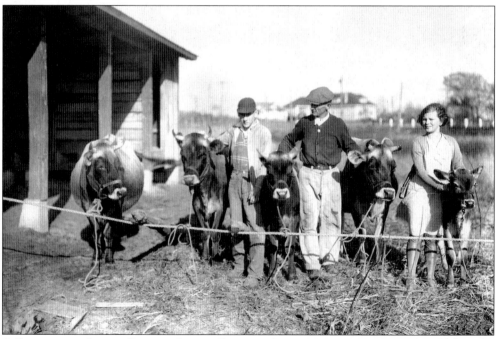

A Family with Jersey Cows in Sussex County, October 29, 1932. Agricultural life in the 1930s was primarily a family enterprise in Delaware. Milking cows and the management of the farm were accomplished as part of a family effort. (Courtesy of the Delaware Public Archives.)

W.L. Mifflin Vineyard, September 4, 1929. While Delaware is not particularly known for its vineyards, some did exist, as this early image shows. Vineyards, however, generally did not do well in the sandy soil along the Atlantic coastal plain. (Courtesy of the Delaware Public Archives.)

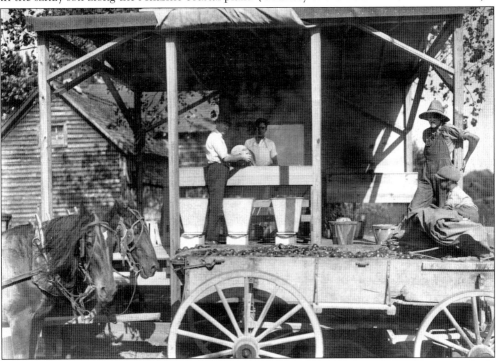

Tomato Inspection Shed in Houston, Delaware, September 2, 1931. Inspection sheds served as a stopping point along the road for produce haulers. Tomatoes formed a large part of Delaware's canning industry in places as diverse as Marshallton, Port Penn, Dover, and Bridgeville. Canning was an important industry that provided off-season employment to watermen. (Courtesy of the Delaware Public Archives.)

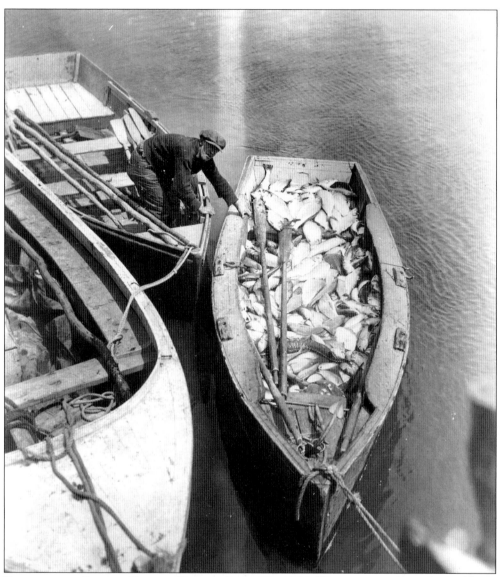

BOATLOAD OF FISH ON BOWERS BEACH, APRIL 22, 1926. Watermen made up the backbone of Delaware's natural-resource economy. They were the commercial fishermen of an earlier time. Watermen lived in the communities of Delaware City, Port Penn, Leipsic, Slaughter Beach, and Bowers Beach. Unlike other parts of the country, Delaware had large breeding populations of atlantic short-nosed sturgeon that supplied caviar for much of the country during the 1920s. (Courtesy of the Delaware Public Archives.)

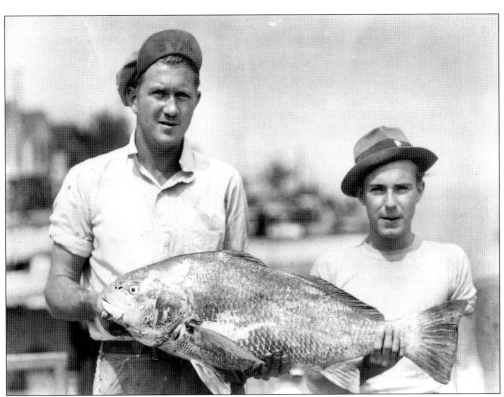

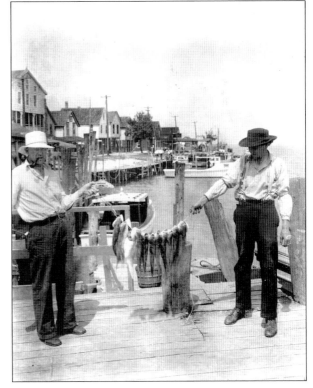

JUNE 12, 1935, A 40-POUND DRUM FISH CAUGHT AT BOWERS BEACH. During the 1920s and 1930s, fishing was an important part of Delaware's overall economic activity. Many fishermen in Kent and New Castle Counties had seasonal work on farms. (Courtesy of the Delaware Public Archives.)

JUNE 7, 1935, A STRING OF TROUT AT BOWERS BEACH. Recreational fishing is also a large part of Delaware's history. Delaware's early tourism often focused on its fishing and outdoor sports. (Courtesy of the Delaware Public Archives.)

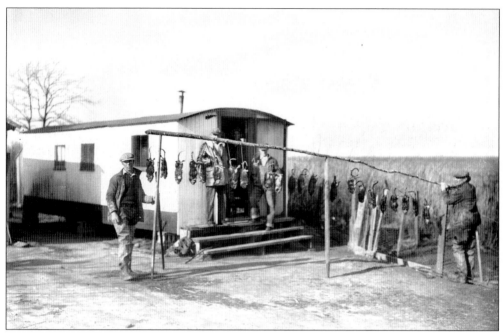

MUSKRAT TRAPPERS AT PORT PENN, DELAWARE, C. 1938. Until the decline of fishing and harvesting of marsh life in the 1950s, the marshes of Delaware provided watermen their livelihood. The waterman's life is a cycle of seasons, each with a different task. Watermen would harvest the fish and crabs from the Delaware River and the turtles and muskrat from the marshes, and they would work on farms at different times during the course of a year. (Courtesy of the Delaware Public Archives.)

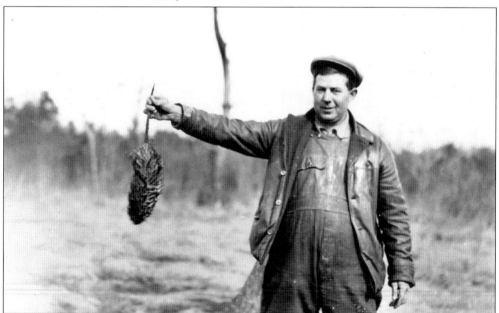

AN UNIDENTIFIED MAN SHOWING OFF HIS CATCH. This man holds up a muskrat in a scene in the marshes outside of Little Creek, Delaware, *c.* 1935. (Courtesy of the Delaware Public Archives.)

THE DOCKS AT BAY VIEW, DELAWARE. This photo illustrates the sailboats and fishing skiffs commonly used on the Delaware River throughout the 1930s. (Courtesy of the Delaware Public Archives.)

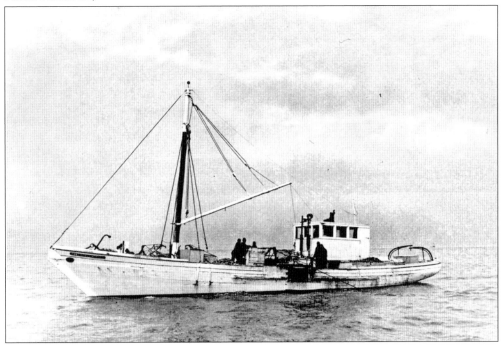

OYSTER SCHOONER AND CREW AT WORK IN THE DELAWARE BAY, APRIL 29, 1924. Oysters were of sufficient quality and number that, throughout the 1930s, they were harvested by fleets in the Delaware River. Many of the oyster dredgers were African Americans. Schooners named *Ishmael, Mamie, Gracie,* and *Doris* were representative of the small fleets that would dredge the Delaware Bay. The schooners provided oysters to restaurants in Wilmington. (Courtesy of the Delaware Public Archives.)

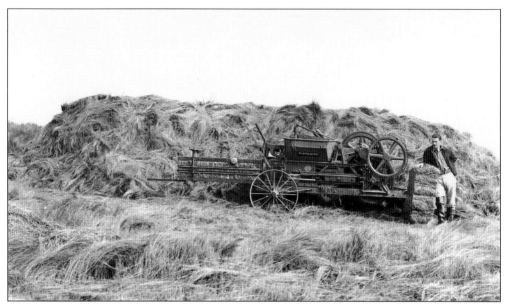

A Marsh Grass Combine, c. 1934. Marsh grass called "salt hay" was an important agricultural commodity in Delaware. Farmers would harvest the salt hay to scatter on their fields during the winter season. (Courtesy of the Delaware Public Archives.)

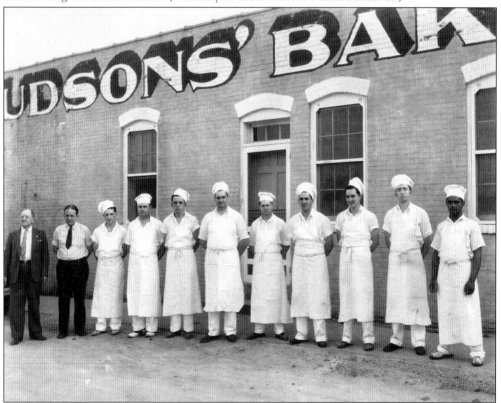

Hudson's Bakers. This photo shows Mr. Hudson and his workers standing outside of the famous bakery in Georgetown, Delaware. (Courtesy of the Delaware Public Archives.)

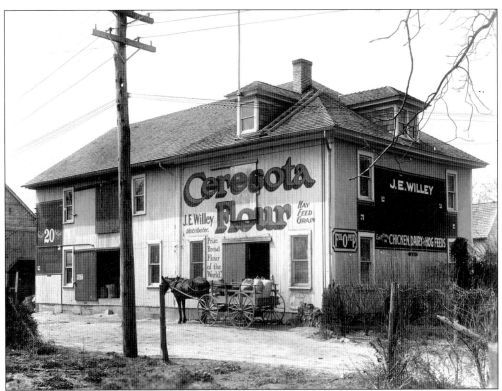

J.E. Willey Distributor, Inc. J.E. Willey provided farm and domestic supplies across the Delmarva Peninsula through the second half of the 20th century. (Courtesy of the Delaware Public Archives.)

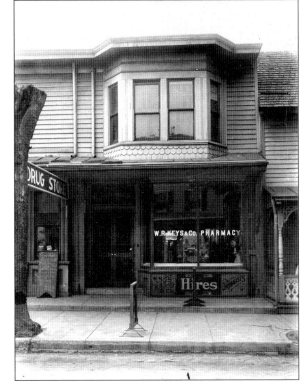

W.R. Keys & Co. Pharmacy, Main Street, Clayton, Delaware. This pharmacy, at Main and Peach Streets, represented a typical small town apothecary *c.* 1936. (Courtesy of the Delaware Public Archives.)

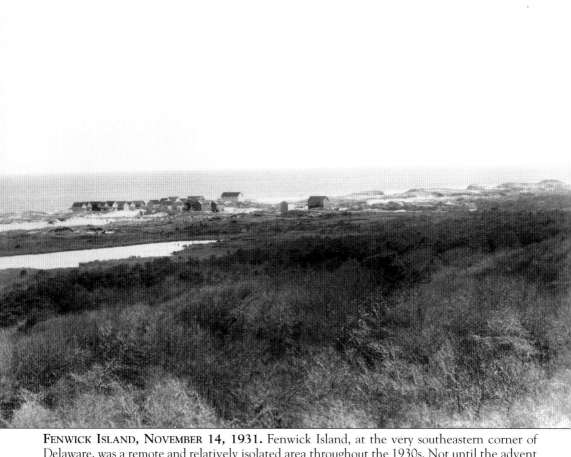

FENWICK ISLAND, NOVEMBER 14, 1931. Fenwick Island, at the very southeastern corner of Delaware, was a remote and relatively isolated area throughout the 1930s. Not until the advent of World War II, when the beach recreation that started in Rehoboth and Oak Orchard had moved down the coast to Dewey and Bethany, did Fenwick Island's relative isolation end. (Courtesy of the Delaware Public Archives.)

Four
CITY LIFE

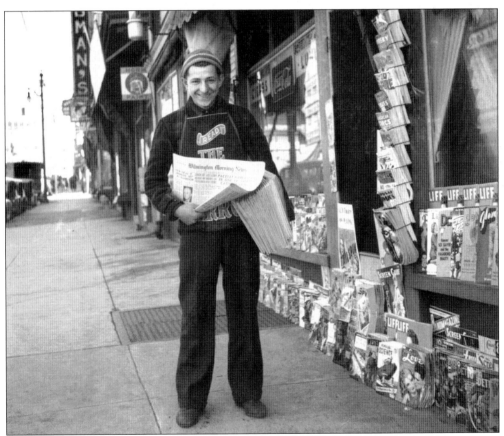

SAMMY AT FOURTH AND KING STREETS, MARCH 1938. The immigrants who came to Wilmington were often small businessmen who operated shops at the markets along King Street. Sammy was the newspaper vendor who gained his reputation by selling newspapers throughout Wilmington during the Great Depression. (Courtesy of the Historical Society of Delaware.)

THE HOME OF REBECCA AND THOMAS MARSHALL AT 2904 MAIN ROAD, ROSELLE, DELAWARE, C. 1929. Their house today would have been along Kirkwood Highway in New Castle County, but was torn down to make Route 141. Suburban growth outside of Wilmington started c. 1895 and expanded rapidly throughout the 1920s and 1930s. (Private Collection.)

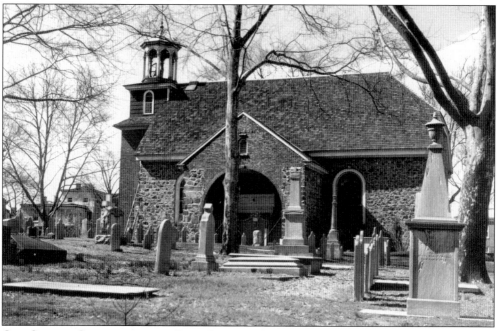

OLD SWEDES CHURCH ON THE EAST SIDE OF WILMINGTON, 1939—ONE OF THE OLDEST CHURCHES IN THE STATE. This picture was taken one year after the tercentenary celebration in 1938. (Courtesy of the Historical Society of Delaware.)

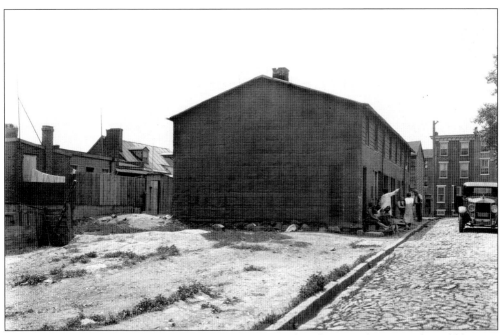

THE SOUTHEAST SIDE OF WILMINGTON, C. 1938. In this photograph, notice the cobblestone streets and early wood tenement houses. These are exceptionally rare architectural forms in the state. Often no more then a room, these houses provided only minimal shelter for the impoverished of the city. (Courtesy of the Historical Society of Delaware.)

A MAN READS LIFE MAGAZINE IN 1939. To say that a picture speaks a thousand words would be an understatement. This photograph of an unidentified man on Market Street offers a rare glimpse into the world of the 1930s. (Courtesy of the Historical Society of Delaware.)

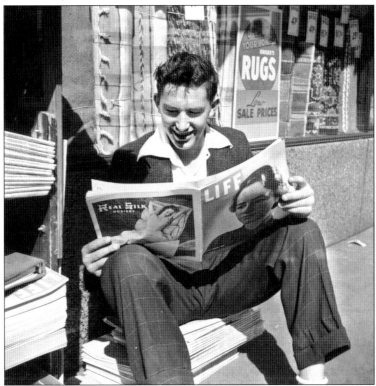

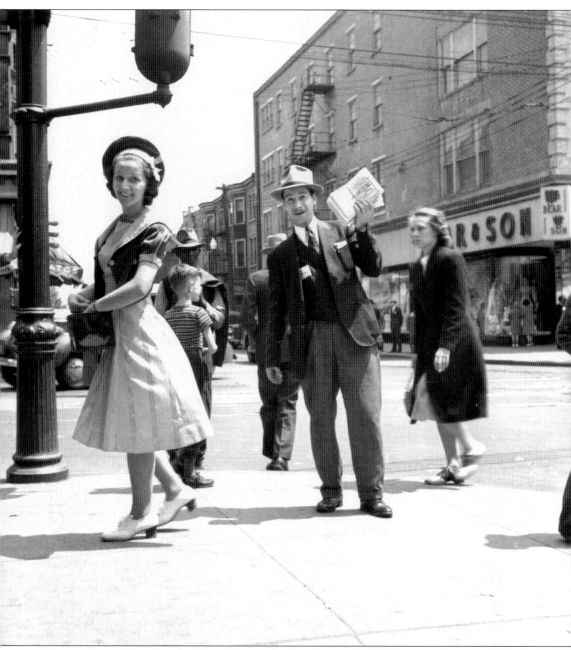

UNIDENTIFIED PEOPLE WALKING ALONG MARKET AND EIGHTH STREETS IN DOWNTOWN WILMINGTON, 1939. More then any other images in the Szymanski collection, this one illustrates the return of optimism and a sense of hopefulness toward the end of the Great Depression. (Courtesy of the Historical Society of Delaware.)

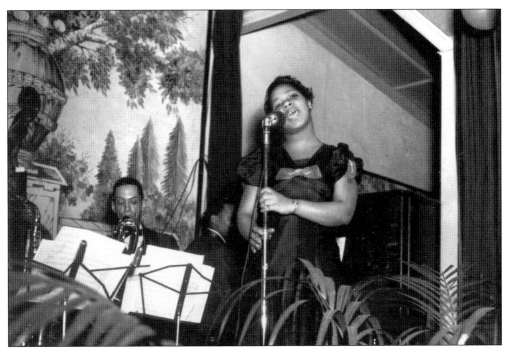

CHARITY BALL IN WILMINGTON, 1939. Jazz music made its way into Wilmington during the 1930s and became a permanent fixture at social events. (Courtesy of the Historical Society of Delaware.)

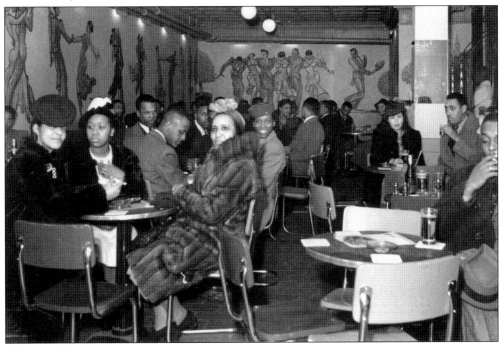

SPOT CAFÉ, MARCH 20, 1940. Throughout the 1930s and until well after the advent of World War II, Wilmington was the home of an active and vibrant jazz scene. (Courtesy of the Historical Society of Delaware.)

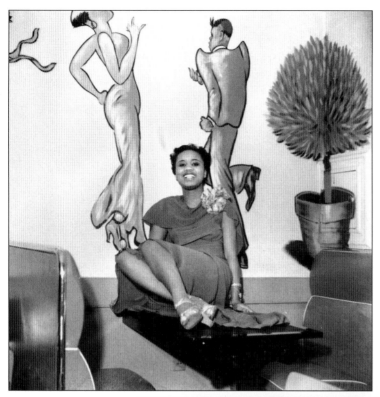

Here is Henry Szymanski's beautiful portrait of a young woman taking her repose during a dance at the Spot Café. (Courtesy of the Historical Society of Delaware.)

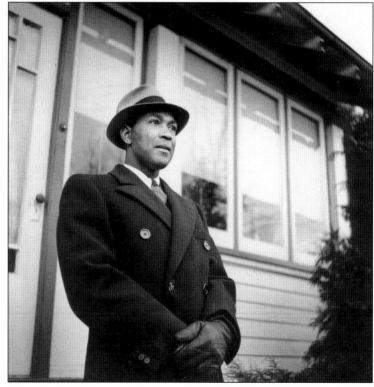

JOHN H. JACKSON, FEBRUARY 2, 1939. This exceptionally sensitive portrait by Henry Szymanski shows Jackson in front of his house. By the end of the 1930s, many black families in Wilmington owned their own homes and had made significant strides toward business ownership in the state. (Courtesy of the Historical Society of Delaware.)

NEWSBOY SELLING THE PHILADELPHIA AFRO-AMERICAN NEWSPAPER ON THE EAST SIDE OF WILMINGTON, MARCH 1941. Newsboys were the children who labored rather than going to school. During the Depression, many children who were healthy were expected to work. (Courtesy of the Historical Society of Delaware.)

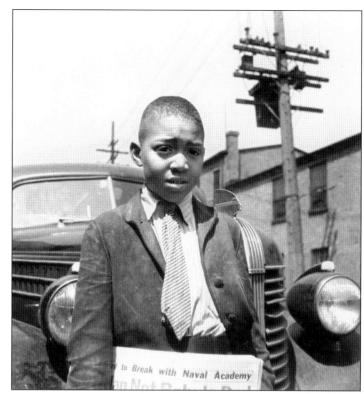

NEWSPAPER VENDOR, MARCH 1941. "Vernon" stands outside of his news shop on the lower east side of the Wilmington. (Courtesy of the Historical Society of Delaware.)

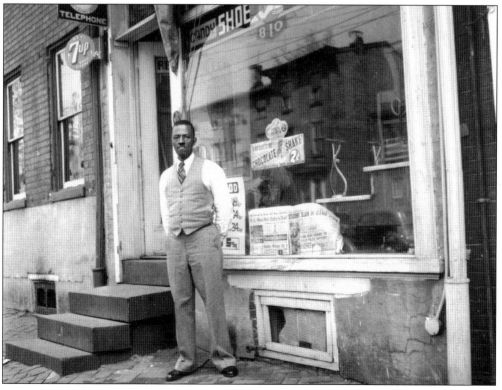

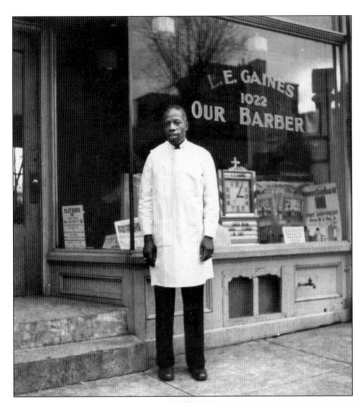

L.E. Gaines, a "colored" Barber, December 31, 1938. Gaines stands in front of his store on the east side of the city. (Courtesy of the Historical Society of Delaware.)

Porters at the Pennsylvania Railroad Station, c. 1938. Rail traffic from Wilmington went to urban areas like Philadelphia and New York in the North as well as to all of lower Delaware. (Courtesy of the Historical Society of Delaware.)

THE RAILROAD BRIDGE AT THE INTERSECTION OF DELAWARE ROUTE 52 AND S. UNION STREET, WILMINGTON, C. 1938. Railroads in Wilmington were used to transport passengers and manufactured goods. (Courtesy of the Historical Society of Delaware.)

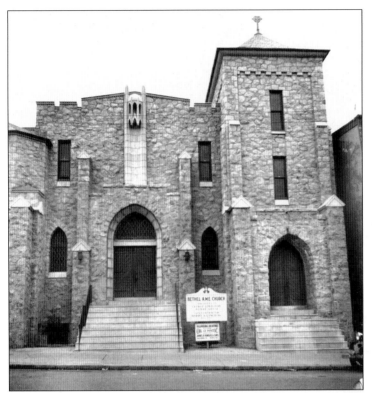

THE BETHEL AME CHURCH, 1939. Throughout Delaware, history in African-American communities is embodied in the dignity of the church and in an adjacent school. These played a pivotal role in educating and shepherding generations of black Delawareans and leading them to economic, social, and educational parity after World War II. (Courtesy of the Historical Society of Delaware.)

REV. A. CHESTER CLARK, JANUARY 2, 1939. Clark served as the spiritual leader of Bethel AME Church for over a decade. (Courtesy of the Historical Society of Delaware.)

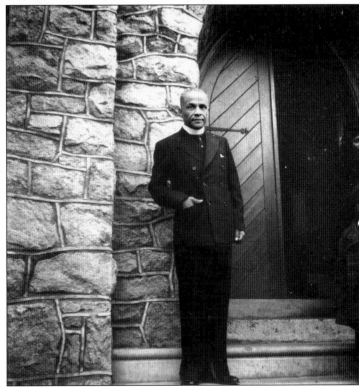

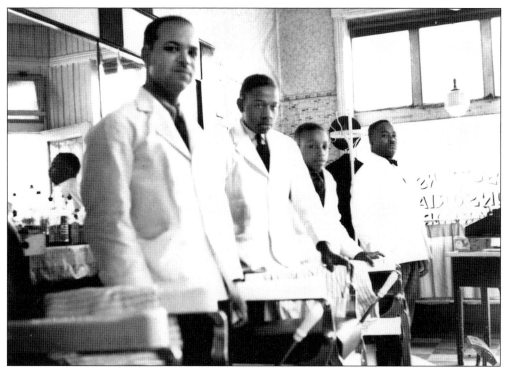

BURTON'S TONSORIAL PARLOR, MARCH 1939. A tonsorial parlor is a barbershop; the Burtons made great advances by being business owners and contributing to their community throughout the 1930s. (Courtesy of the Historical Society of Delaware.)

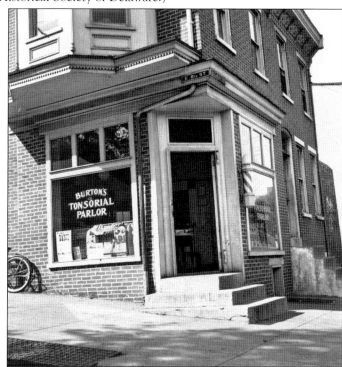

BURTON'S TONSORIAL PARLOR, MARCH 1939. An exterior view of the Burton's building on Wilmington's east side. (Courtesy of the Historical Society of Delaware.)

GARRETT SETTLEMENT HOUSE, JUNE 1939. Settlement houses provided children and families with shelter, food, and a modicum of education. Jane Russell introduced them into the United States in 1908. They came into their own as neighborhood houses and community centers to provide family support in the inner cities during the Depression. (Courtesy of the Historical Society of Delaware.)

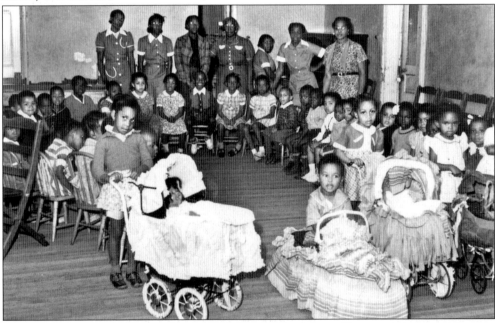

GARRET SETTLEMENT HOUSE, JUNE 1939. Garrett Settlement House acted as an orphanage for the African-American children of the city. The desperation of poverty often caused families to orphan their children or to leave them with a settlement house while they sought full-time, regular employment and a place for the family to stay. (Courtesy of the Historical Society of Delaware.)

MR. WHITE, THE OWNER OF THE "COLORED" QUICK SERVICE STATION, FEBRUARY 23, 1938. This station, located on the east side of Wilmington, was famous for its service. (Courtesy of the Historical Society of Delaware.)

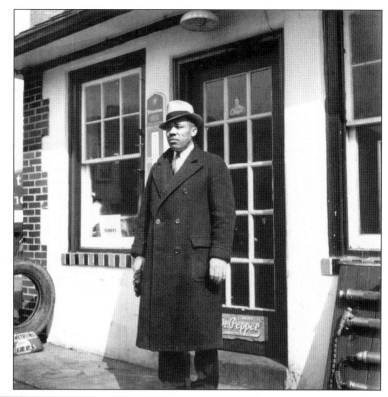

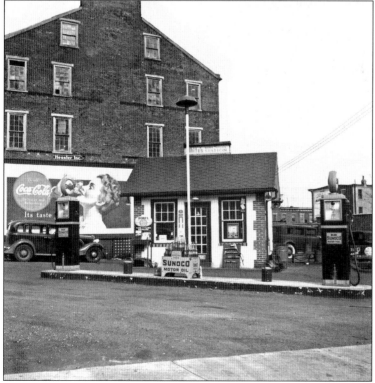

WHITE'S QUICK SERVICE STATION, FEBRUARY 23, 1938. Car ownership among African Americans was relatively low in most of Delaware during the 1930s. Mr. White's service station served both whites and blacks in the city. (Courtesy of the Historical Society of Delaware.)

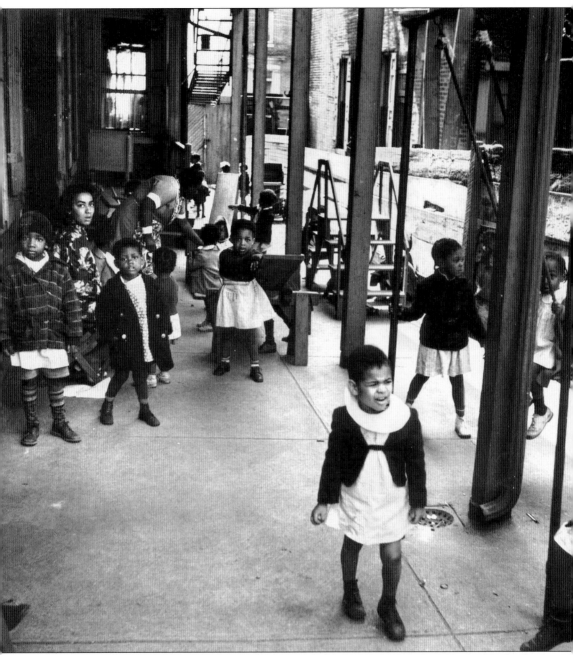

St. Michael's Day Nursery for Colored Children in Wilmington, 1940. Finding work was never easy during the Depression, and for the African-American population of the state, both husband and wife often worked to provide for their family. (Courtesy of the Historical Society of Delaware.)

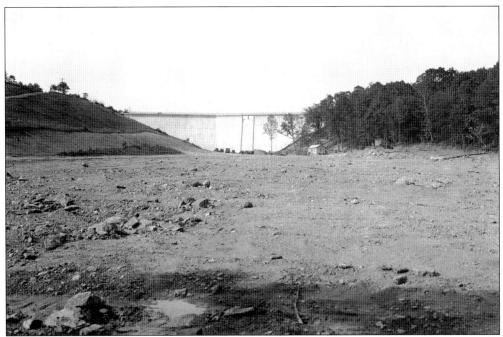

Hoopes' Reservoir Dam Outside of Centerville, Delaware, c. 1938. This dam was a major infrastructural project that took place to provide jobs to the underemployed and meet the water needs of the city of Wilmington. (Courtesy of the Historical Society of Delaware.)

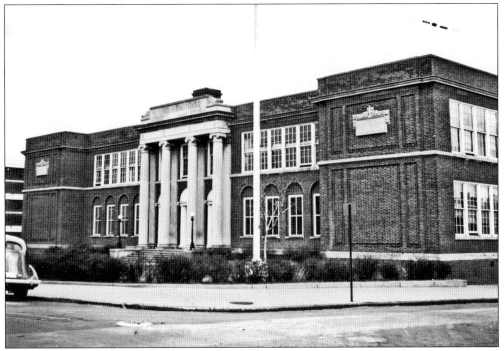

Howard High School, 1940. This school was representative of the massive combined elementary, junior, and senior high schools that P.S. DuPont built for the state. (Courtesy of the Historical Society of Delaware.)

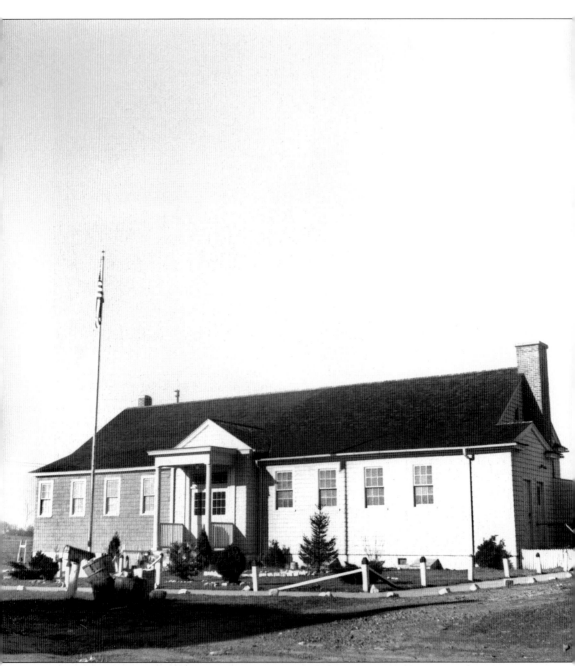

THE BUTTONWOOD SCHOOL, MARCH 3, 1939. This school outside of Wilmington was representative of the two-room, Colonial-revival schoolhouses that P.S. Dupont funded across the state. Whereas Howard was representative of massive construction, the Buttonwood School illustrates the typical rural schoolhouse. (Courtesy of the Historical Society of Delaware.)

THE WILMINGTON YWCA, JANUARY 14, 1939. The opening of the YWCA represented a victory for African Americans throughout New Castle County. (Courtesy of the Historical Society of Delaware.)

MRS. HELEN MASLEY AND MRS. ALBERTA RUSSELL WILLIAMS IN FRONT OF THE WILMINGTON YWCA, JANUARY 1, 1939. Social service agencies providing guidance to young African Americans grew directly out of the experience of segregation that Delaware blacks lived with during the Great Depression. (Courtesy of the Historical Society of Delaware.)

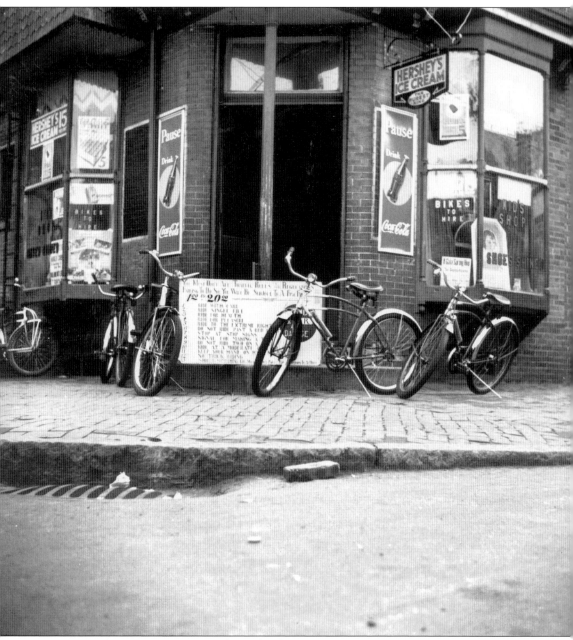

"The Kid's Shop," c. 1938. The Kid's Shop sits on the east side in Wilmington. Locally owned stores were the norm in Wilmington during the era before the shopping center. The local stores of the city served as the place to shop and a place for kids to congregate. (Courtesy of the Historical Society of Delaware.)

Five

BASEBALL AND RECREATION

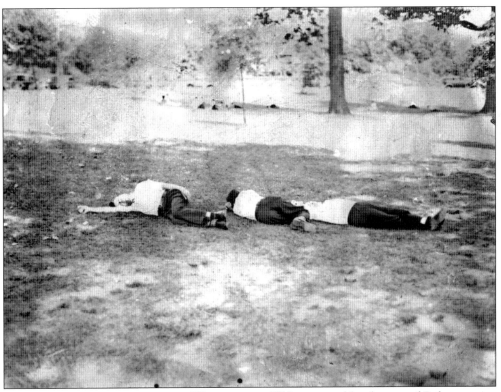

ASLEEP AT BRANDYWINE PARK IN WILMINGTON. Wilmington, like the rest of Delaware, was notoriously hot during the summer of 1940. This photograph shows the best form of recreation during hot weather. (Courtesy of the Delaware Public Archives.)

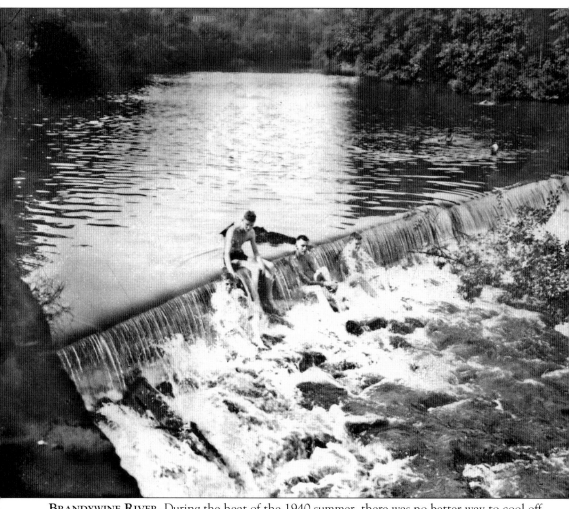

BRANDYWINE RIVER. During the heat of the 1940 summer, there was no better way to cool off than in the Brandywine River. (Courtesy of the Delaware Public Archives.)

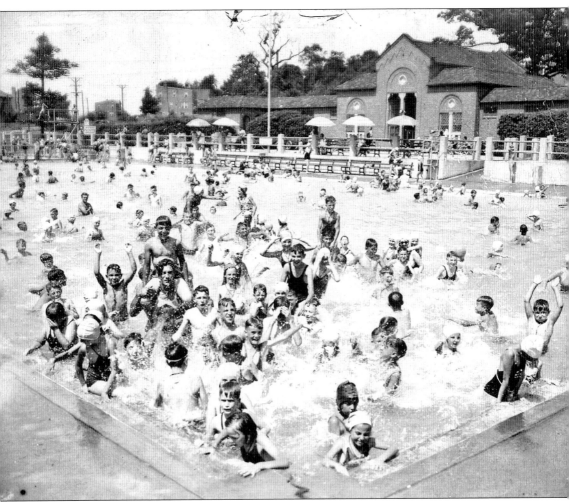

Children Swimming at the Wilmington Public Pool during the Hot Summer of 1940. Public pools were a source of recreation as well as a source of constant concern for parents who feared that their children might be exposed to polio. (Courtesy of the Delaware Public Archives.)

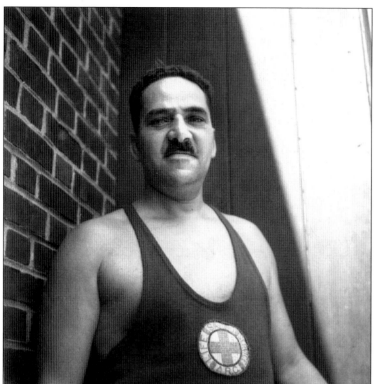

EVERY POOL NEEDS A LIFEGUARD. This is a portrait of the lifeguard at the Kruse public pool for colored children. (Courtesy of the Historical Society of Delaware.)

P.S. DUPONT HIGH SCHOOL FOOTBALL TEAM, C. 1941. During the Depression, football and other physical activities were organized in Delaware public schools for the first time. (Courtesy of the Delaware Public Archives.)

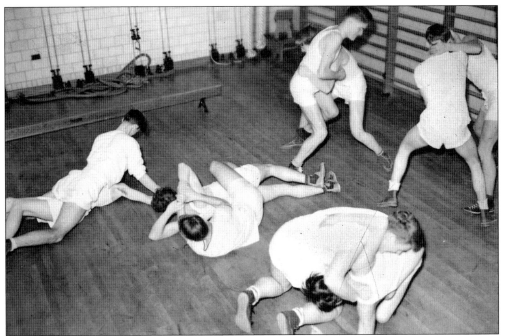

"PHYSICAL ACTIVITY TO PREPARE YOUTHS FOR WAR," C. 1941. This photo caption illustrates why physical education was given such priority during the latter years of the Depression. These children wrestling would be the men who defended America during World War II. (Courtesy of the Delaware Public Archives.)

"THE FIRST DAY OF THE GAME," MAY 1, 1942. Shortly after the start of World War II, Delaware built Wilmington Stadium for its baseball team, the Blue Rocks. Throughout the Depression, Delaware teams and players traveled across the United States competing in the minor leagues, but until 1942 there were no professional stadiums in Delaware. (Courtesy of the Delaware Public Archives.)

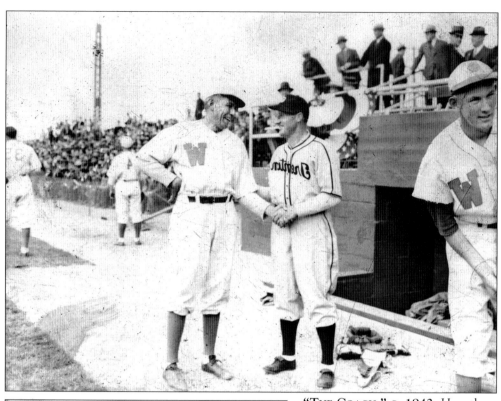

"THE COACH," C. 1942. Here the coach of the Wilmington Blue Rocks and the coach of the Trenton Thunder from New Jersey shake hands and share a laugh before the game. (Courtesy of the Delaware Public Archives.)

THE BALTIMORE ORIOLES PITCHER PREPARES TO TAKE ON THE WILMINGTON BLUE ROCKS IN 1942. By the end of the Great Depression, baseball was known as the American sport. (Courtesy of the Delaware Public Archives.)

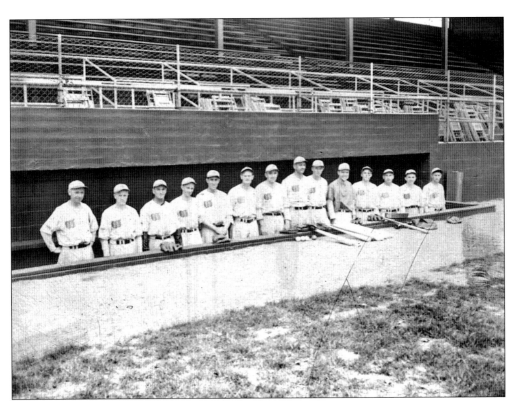

THE WILMINGTON BLUE ROCKS IN THEIR DUGOUT, C. 1942. The Wilmington Blue Rocks were Delaware's baseball team. Minors from the Eastern Shore League would compete fiercely for a spot on the team. (Courtesy of the Delaware Public Archives.)

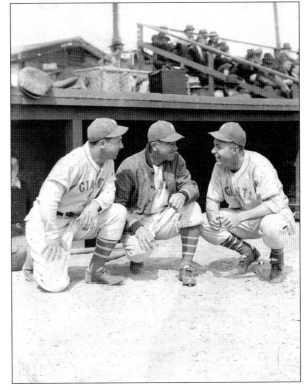

THE COACH AND PLAYERS OF THE GIANTS IN THE EASTERN SHORE BASEBALL LEAGUE CONFER, C. 1942. The Eastern Shore Baseball League included a number of local franchises from across the Delmarva Peninsula. (Courtesy of the Delaware Public Archives.)

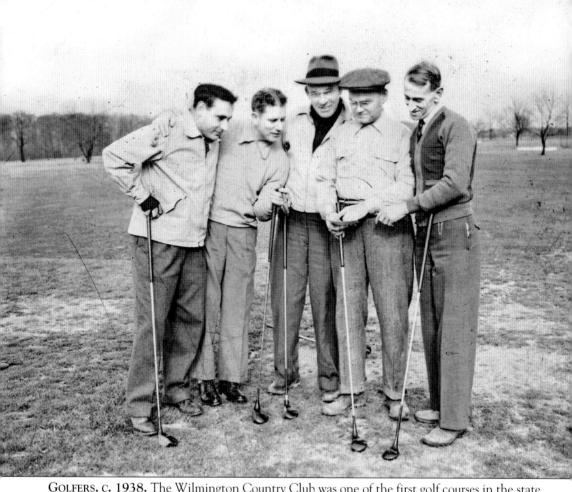

GOLFERS, C. 1938. The Wilmington Country Club was one of the first golf courses in the state and the first golf course open for membership. Here, five golfers tally the score for a day's game. (Courtesy of the Delaware Public Archives.)

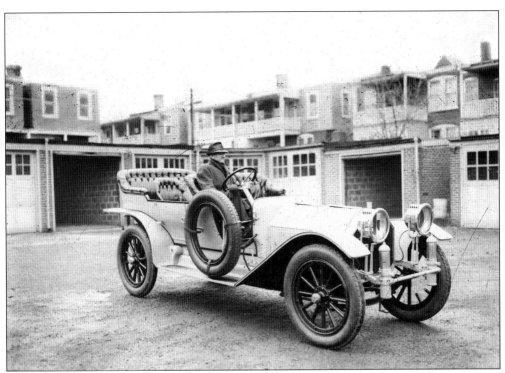

THE NEW CASTLE COUNTY AUTOMOBILE CLUB. This club was a favorite for those who could afford to enjoy recreational motoring. Here, Capt. Charles J. Lugenot drives a 1910 Pierce Arrow owned by Francis V. DuPont, c. 1940. (Courtesy of the Delaware Public Archives.)

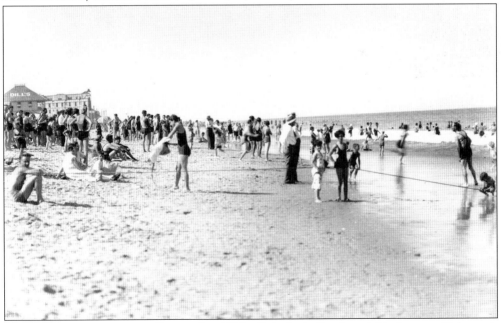

REHOBOTH BEACH, 1931. During the 1930s, Rehoboth Beach quickly became Delaware's favorite resort town. This picture shows the famous Dills Inn in the background while people enjoy the sand and ocean. (Courtesy of the Delaware Public Archives.)

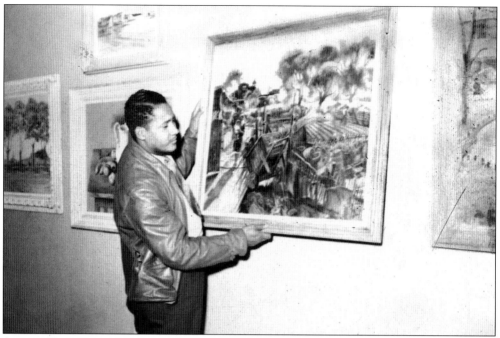

ARTIST EDWARD LOPER, C. 1939. Here, Loper receives an award for the best watercolor painting in Delaware. (Courtesy of the Delaware Public Archives.)

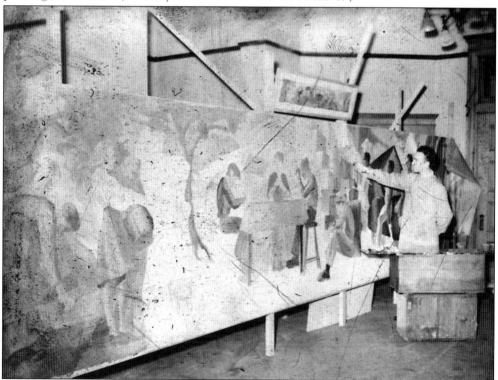

LESLIE MACKLEM, C. 1939. Here, the famous WPA mural artist is at work on a post office mural in his studio. (Courtesy of the Delaware Public Archives.)

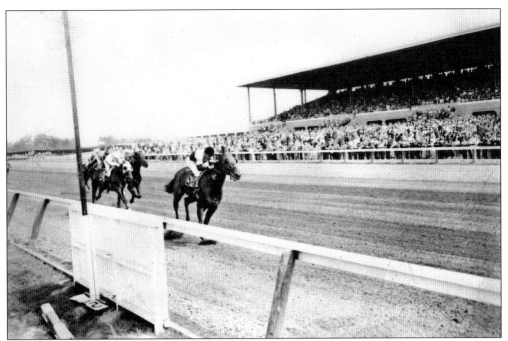

DELAWARE PARK IN STANTON, C. 1941. Horseracing had always been popular in rural Delaware, but until the Depression, there were no professional horseracing tracks in the state. This changed in 1940 when Delaware Park was developed. (Courtesy of the Delaware Public Archives.)

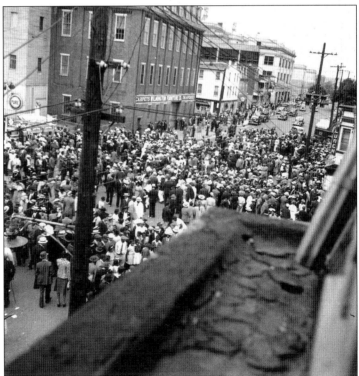

THE BIG QUARTERLY, AUGUST 27, 1939. This event brought the east side communities of Wilmington together for entertainment once a year. It was the biggest party in the city of Wilmington. (Courtesy of the Historical Society of Delaware.)

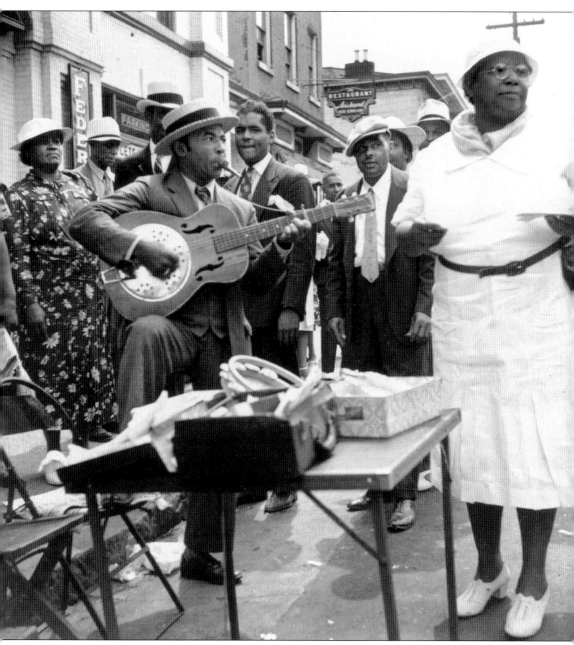

ENTERTAINMENT AT THE BIG QUARTERLY, AUGUST 27, 1939. The Big Quarterly is an annual African-American celebration in the city. Today, the event is open to everyone, but in the segregated past, it was reserved for African Americans. (Courtesy of the Historical Society of Delaware.)

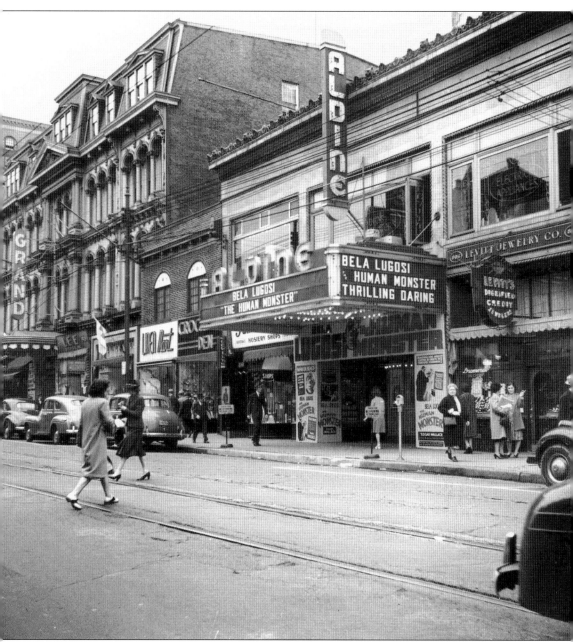

THE ALDINE THEATER IN WILMINGTON, JUNE 1930. The Aldine is considered the most historically important theater in the city of Wilmington. (Courtesy of the Historical Society of Delaware.)

THE ALDINE THEATER, JUNE 1930. For children in the city of Wilmington, the Aldine Theater was one of the largest congregation points. Children would try to slip past the guards to catch a glimpse of their favorite movie stars. (Courtesy of the Historical Society of Delaware.)

Six

THE CIVILIAN CONSERVATION CORPS
We Can Take It!

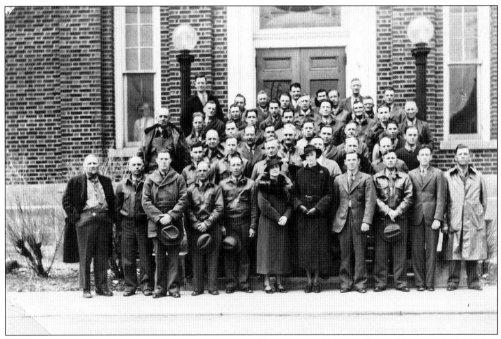

THE DELAWARE MOSQUITO CONTROL BOARD, REHOBOTH BEACH POST OFFICE, 1934. Mrs. Mary Wilson Thompson is in the front row. She is credited with leading the movement to bring the CCC to Delaware with Col. J. Corkran in 1931. (Courtesy of the Delaware Public Archives.)

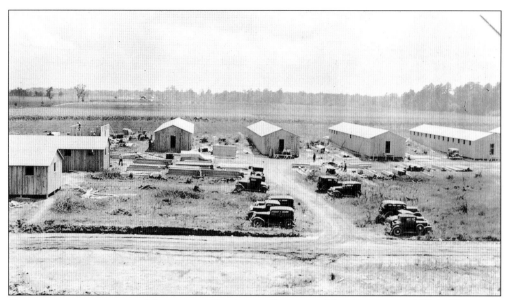

CONSTRUCTION OF THE MOSQUITO CONTROL CAMP IN MAGNOLIA, C. 1934. Company 1295MC at Magnolia was responsible for ditching and mosquito control in the marshes. (Courtesy of the Delaware Public Archives.)

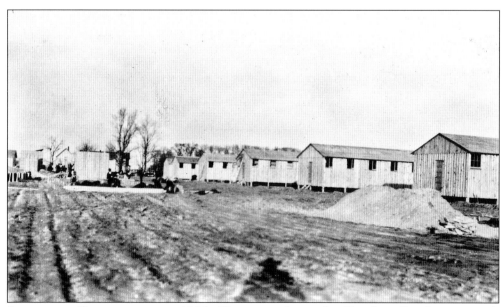

SLAUGHTER BEACH CAMP, C. 1935. This view shows the Slaughter Beach camp with construction finished. (Courtesy of the Delaware Public Archives.)

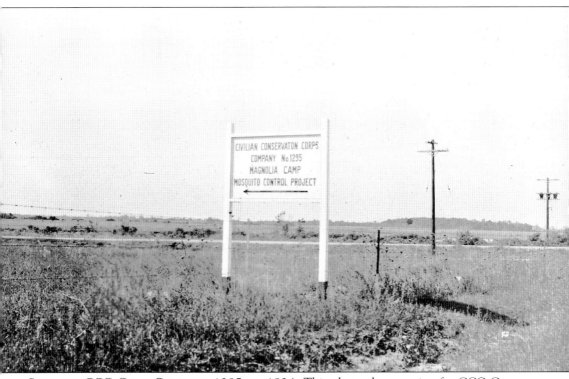

SIGN FOR CCC CAMP COMPANY 1295, C. 1934. This photo shows a sign for CCC Camp Company 1295 in Magnolia, Delaware. (Courtesy of the Delaware Public Archives.)

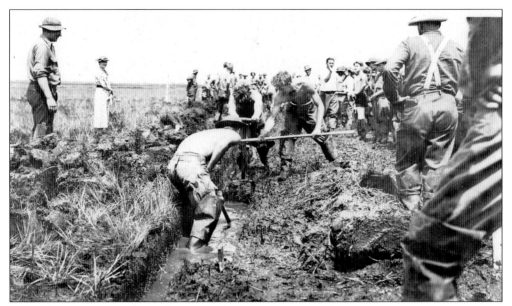

COMPANY 1295, C. 1935. Here is the company at work, with Mrs. Thompson supervising their ditching. (Courtesy of the Delaware Public Archives.)

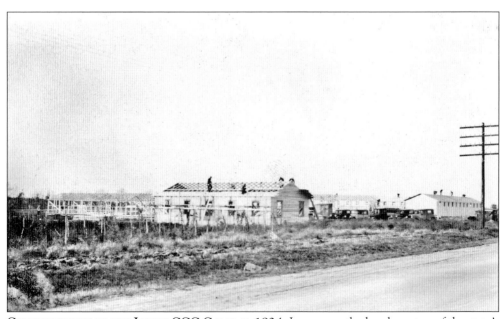

CONSTRUCTION OF THE LEWES CCC CAMP, C. 1934. Lewes was the headquarters of the state's mosquito control effort throughout the Depression. (Courtesy of the Delaware Public Archives.)

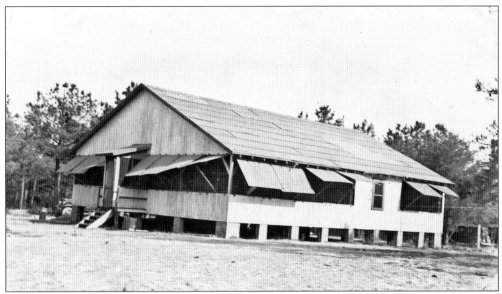

CCC Mess Hall, Lewes Beach, Delaware, May 21, 1934. The CCC provided men enrolled in the program three square meals each day of service. In addition, the men were required to save all but $5 of their pay to send to their families. (Courtesy of the Delaware Public Archives.)

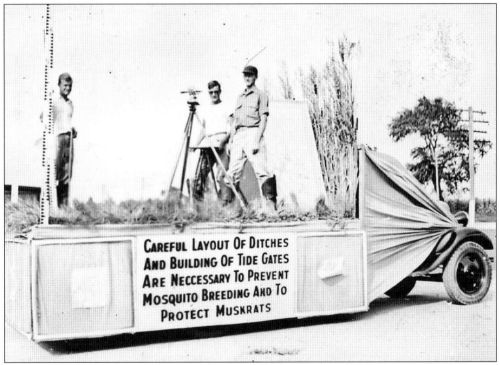

CAREFUL LAYOUT OF DITCHES AND BUILDING OF TIDE GATES ARE NECCESSARY TO PREVENT MOSQUITO BREEDING AND TO PROTECT MUSKRATS

"Careful Layout of Ditches and Building of Tide Gates are Necessary to Prevent Mosquito Breeding and Protect Muskrats"—CCC at the State Fair, Harrington, c. 1935. The CCC participated in a variety of public outreach events across the state to encourage conservation and mosquito control. (Courtesy of the Delaware Public Archives.)

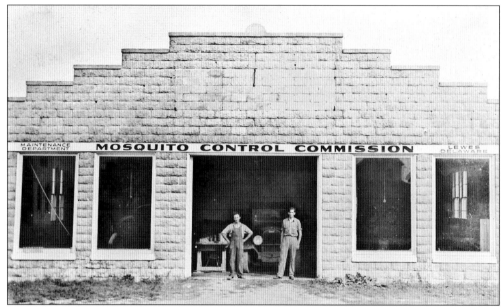

MOSQUITO CONTROL COMMISSION HEADQUARTERS, LEWES BEACH, DELAWARE, C. 1934. Mosquito control headquarters served as the central location for supplies and information concerning mosquito control in Delaware. After the Depression, the building was converted into a storage site, then a garage, and finally an antique and beach gift shop. (Courtesy of the Delaware Public Archives.)

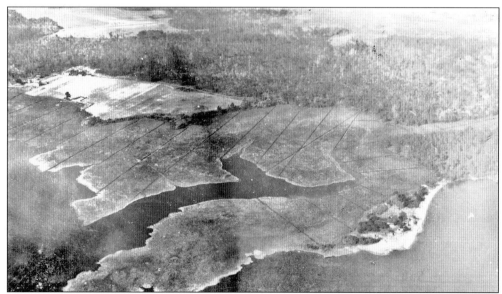

AERIAL VIEW OF DITCHING NEAR BROADKILL BEACH, C. 1938. The ditching that the CCC completed altered the landscape of Delaware. If you look at the state from the air, there are thousands of ditch lines radiating out from the marshes to the Delaware Bay. (Courtesy of the Delaware Public Archives.)

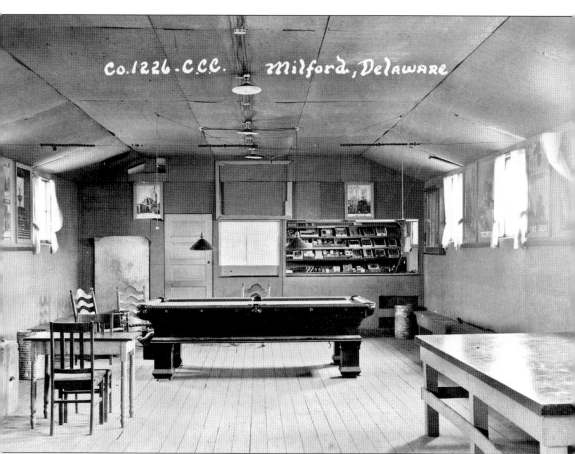

CCC Co. 1226, Milford, Delaware, Interior of the Recreation Quarters, c. 1934.
In exchange for the hard work, the men of the CCC received food and educational and recreation opportunities they would not have otherwise received. (Courtesy of the Delaware Public Archives.)

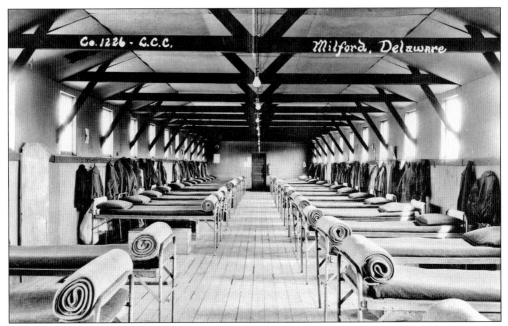

CCC Co. 1226, Milford, Delaware, Interior Sleeping Quarters, c. 1934. Sleeping quarters at a CCC camp were sparse and barracks-like. Still, for those members of the CCC with no home, the program offered relatively comfortable accommodations. (Courtesy of the Delaware Public Archives.)

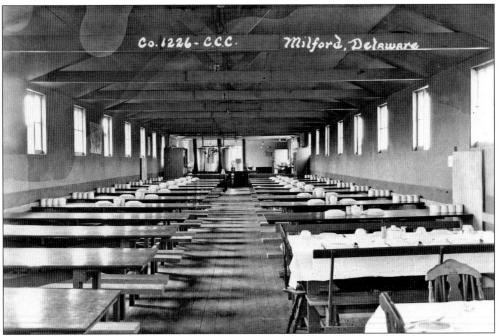

CCC Co. 1226, Milford, Delaware. Chet Stehecki took this rare interior view of a CCC mess hall between 1934 and 1936. This photograph illustrates the emphasis on the cleanliness and sense of order the experience was meant to instill in young men. (Courtesy of the Delaware Public Archives.)

CCC Workshop, Lewes, Delaware, Winter 1935-1936. CCC workshops were usually hubs of activity, being the storeroom for supplies, shovels, picks, and other equipment as well as offering classes in woodwork and other crafts. (Courtesy of the Delaware Public Archives.)

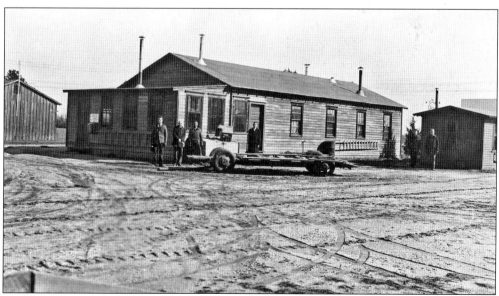

CCC Workshop, Lewes, Delaware, Spring 1936. This never-before-published photograph shows the CCC workshop at Lewes. (Courtesy of the Delaware Public Archives.)

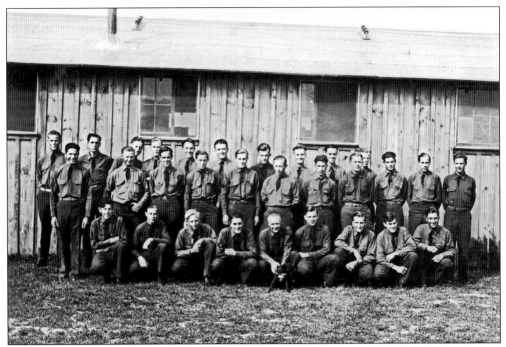

FIRST PLATOON, CCC CO. 1224, LEWES, DELAWARE, 1934. The CCC was divided into companies. Over 15 companies of the CCC served in Delaware during the Depression. (Courtesy of the Delaware Public Archives.)

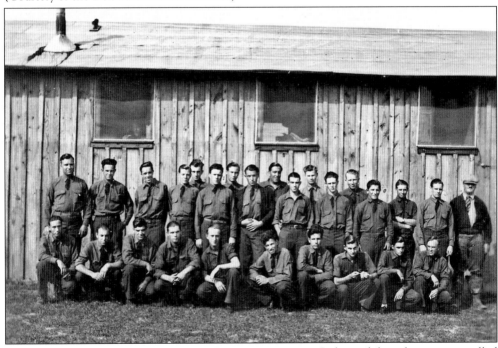

FOURTH PLATOON, CO. 1224, LEWES, DELAWARE, 1934. Order and discipline were instilled in young men through life in the barracks as well as the necessary demands of orderly drills and hard work. (Courtesy of the Delaware Public Archives.)

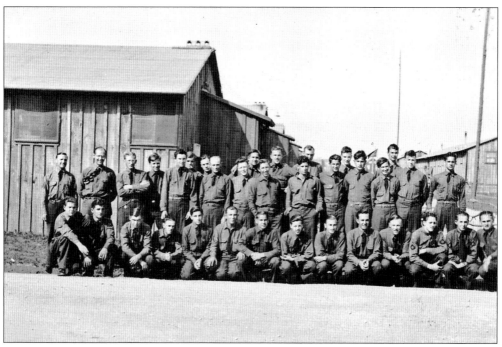

FIFTH PLATOON, CCC CO. 1224, LEWES, DELAWARE, 1934. Orderly formations were part of the monthly routine for men serving in the CCC. (Courtesy of the Delaware Public Archives.)

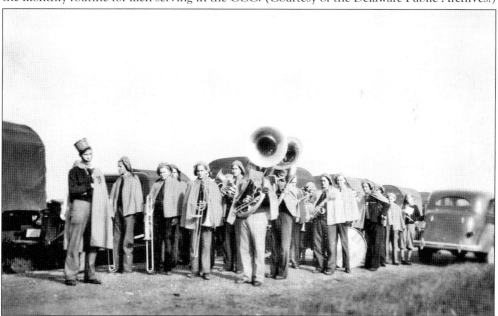

CCC CAMP BAND, MAGNOLIA, C. 1936. Many of the men who entered the CCC were illiterate. The CCC would take young recruits and train them to do productive work. In addition, they had time for recreation and to learn to play musical instruments and march in formation, training that would be very useful by 1941. In this, the CCC was like the WPA, who sought to provide artists, writers, historians, architects, and other professionals steady employment. (Courtesy of the Delaware Public Archives.)

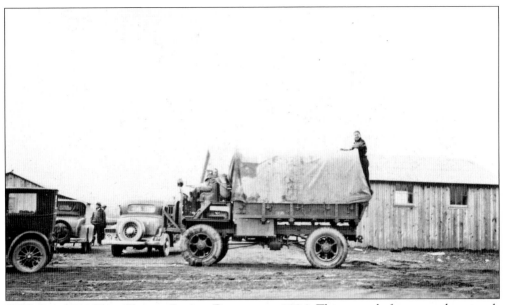

CCC Co. 1224 Camp Truck, Lewes, Delaware, 1934. This never-before-seen photograph illustrates the daily activities of camp life. (Courtesy of the Delaware Public Archives.)

Forestry Official Supervising the CCC Harvesting of Marsh Grass, 1934. Starting in 1934, some of Delaware's CCC companies were moved under the supervision of the Forestry Department. (Courtesy of the Delaware Public Archives.)

CCC Mispillion Marsh Gate, c. 1934. Floodgates prevent the marshes from filling with too much stagnant water and increase the amount of tidal water that enters the marshes. (Courtesy of the Delaware Public Archives.)

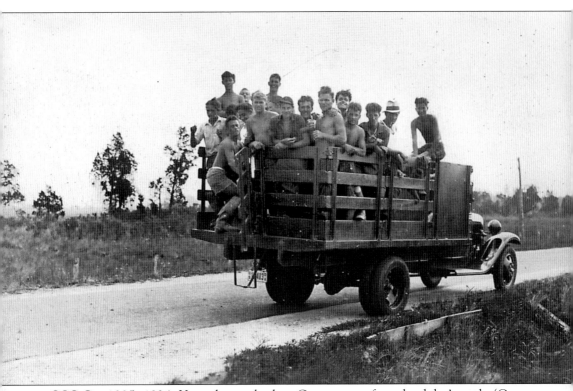

CCC Co. 1225, 1934. Here, they go back to Georgetown after a hard day's work. (Courtesy of the Delaware Public Archive.)

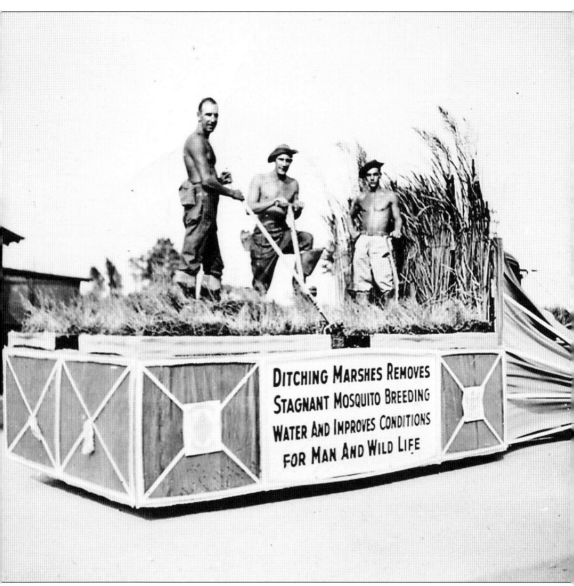

"Ditching Marshes Removes Stagnant Mosquito Breeding Water and Improves Conditions for Man and Wild Life," c. 1934. Here is the CCC at the Harrington State Fair. (Courtesy of the Delaware Public Archives.)

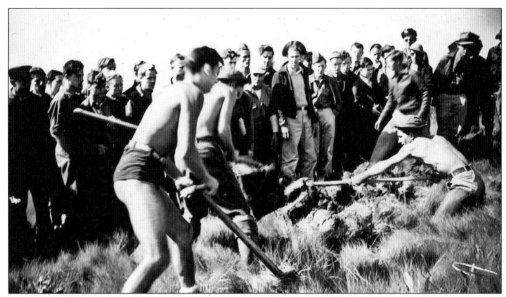

SOD CUTTING. Here, CCC Co. 1295 is competing against other camps in a test of strength at the CCC annual field meet in May 1936. (Courtesy of the Delaware Public Archives.)

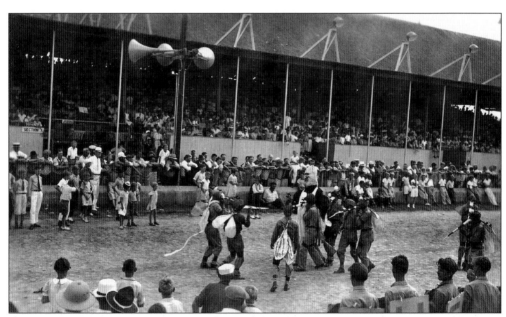

MOSQUITO COSTUMES, c. 1934. In this photo, CCC men are conducting public outreach by dressing up in mosquito costumes at the Harrington State Fair. (Courtesy of the Delaware Public Archives.)

CCC Camp in Lewes, Delaware.
Here, General Cole, Colonel Chase, and Colonel Grant inspect the camp in 1935. (Courtesy of the Delaware Public Archives.)

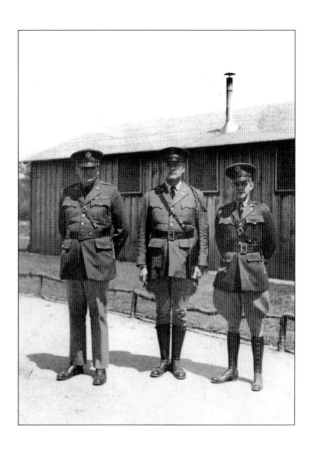

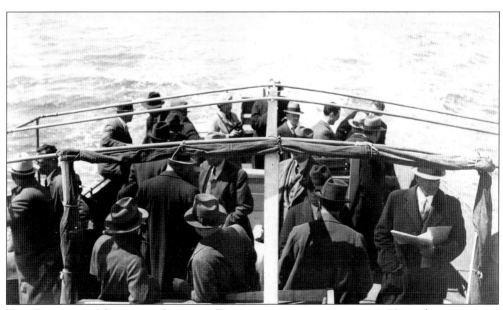

The Delaware Mosquito Control Engineering group, c. 1934. Here, the group is on a tour off the coast of Lewes, Delaware. (Courtesy of the Delaware Public Archives.)

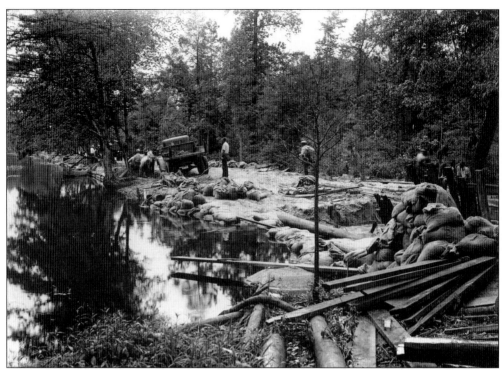

CCC Co. 1225 in Georgetown, Delaware, c. 1934. Starting in 1934, William Taber, the Delaware state forester, began using the CCC to build up Redden State Forest (see appendix 1). This picture shows the CCC barricading a roadway after heavy rains. (Courtesy of the Delaware Public Archives.)

CCC in Lewes, Delaware, Digging Drainage along the Canal, c. 1934. Legend says that the CCC ran into a spring they called the "fountain of youth." Later, a pavilion was put up to commemorate the site. In this photo, we see men from the camp digging the drainage ditch. (Courtesy of the Delaware Public Archives.)

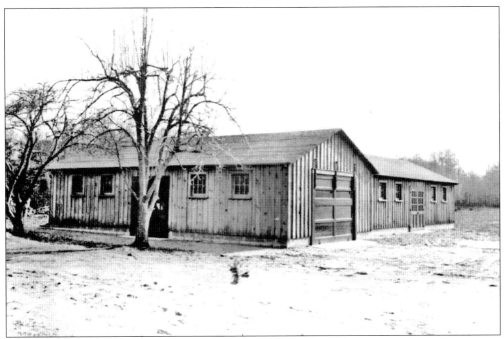

CCC Camp Workshop at Redden State Forest, c. 1934. The construction of Redden State Forest was the crowing achievement of William Taber, the state forester. (Courtesy of the Delaware Public Archives.)

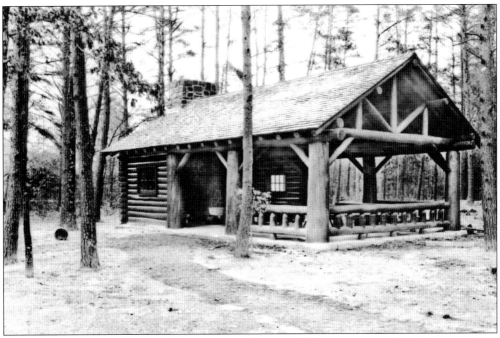

CCC Camp recreation pavilion, Modern Picture. The structure was built between 1935 and 1936. (Private Collection.)

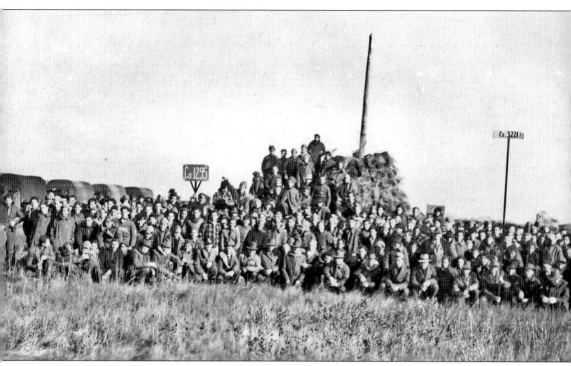

CCC Co. 1295 at Their Farewell Ceremony in July 1937, Prime Hook Beach. The CCC are sitting on the mound they made for the ceremony. (Courtesy of the Delaware Public Archive.)

REDDEN STATE FOREST WORKSHOP, C. 1935. This rare photograph illustrates the Redden State Forest workshop being used shortly after its construction. (Courtesy of the Delaware Public Archives.)

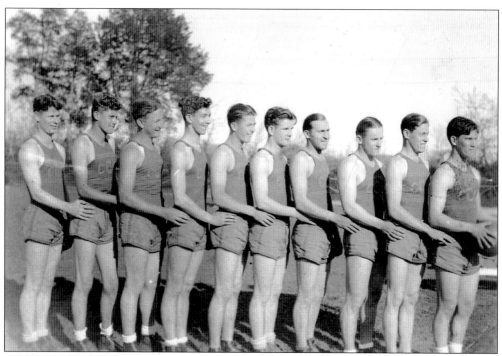

CCC Men's basketball Team, c. 1936. Here the team poses for a photograph. As in the schools, physical education for the young men in the CCC was paramount. It also served as a source of recreation, teamwork, and fun for men who spent most of their time doing grueling ditching, roadwork, and construction. (Courtesy of the Delaware Public Archives.)

Two Young Men Playing at CCC Camp No. 2, c. 1936. These men are from Company 1295. (Courtesy of the Delaware Public Archives.)

CCC Camp No. 2, c. 1936. The young men from the camp are waving to the photographer as he drives off. (Courtesy of the Delaware Public Archives.)

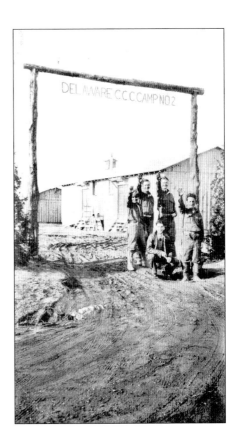

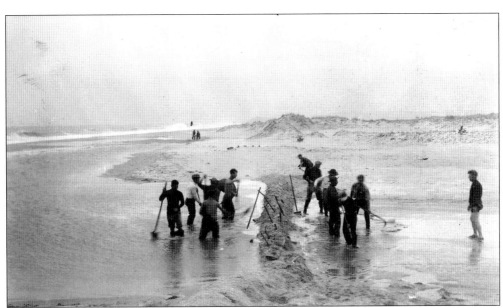

FLOOD RESPONSE, c. 1934. Here, the CCC is trying to prevent beach erosion during a flood event. The CCC were the first disaster responders and erosion and flood prevention specialists in Delaware. (Courtesy of the Delaware Public Archives.)

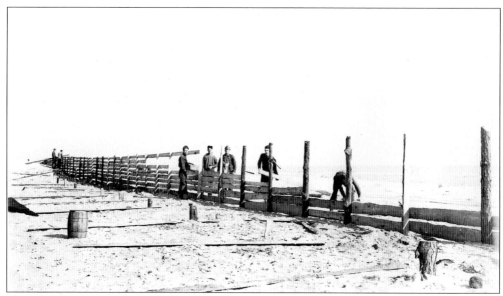

The CCC at Lewes Beach, c. 1935. Here, the CCC are building sand dunes and implementing erosion control methods. (Courtesy of the Delaware Public Archives.)

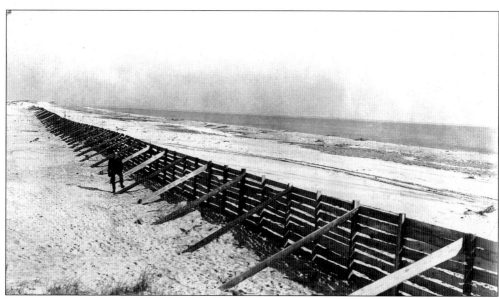

CCC at Lewes Beach, c. 1935. Here are the finished erosion control barriers. (Courtesy of the Delaware Public Archives.)

MISPILLION LIGHT HOUSE, C. 1935. This photo shows the lighthouse after the construction of CCC beach erosion barriers. (Courtesy of the Delaware Public Archives.)

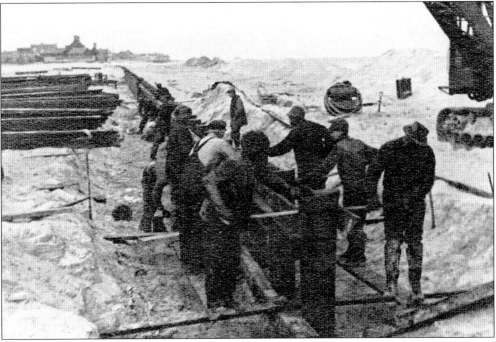

CCC AT LEWES BEACH, C. 1935. Here the CCC is building the foundation for the erosion control bulwark and creating sand dunes. The CCC built many of the sand dunes along Delaware's beaches to prevent their erosion and to conserve sand. (Courtesy of the Delaware Public Archives.)

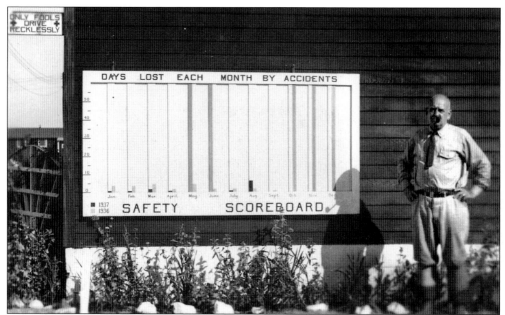

CCC "Safety Scoreboard" for Service in Lewes, 1937. The discipline of the CCC could not prevent every accident that could occur, but it did prevent most of the accidents that the men were likely to encounter. When men would get hurt or were ill, the CCC would pay for their treatment. (Courtesy of the Delaware Public Archives.)

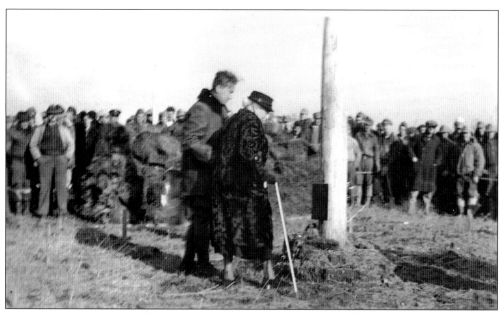

Time Capsule at Prime Hook Beach, July 1937. Ms. Mary Wilson Thompson places a time capsule at Prime Hook Beach to remember life in the CCC. As 1937 drew near, the CCC began to decommission across the state. The time capsule was then covered with hundreds of cubic yards of sod to make the mound that is inside Prime Hook National Wildlife Refuge today. (Courtesy of the Delaware Public Archives.)

MOSQUITO PAGEANT. Here is the CCC gathering at the mosquito pageant in July 1937. (Courtesy of the Delaware Public Archives.)

FORT SALISBURY GUN PLACEMENTS. When the CCC decommissioned from 1937 to 1938, the men were assigned to the United States Army, and many served at Fort Miles and Fort Salisbury. This picture illustrates the cadets at the Fort Salisbury gun placements. (Courtesy of the Delaware State Archives.)

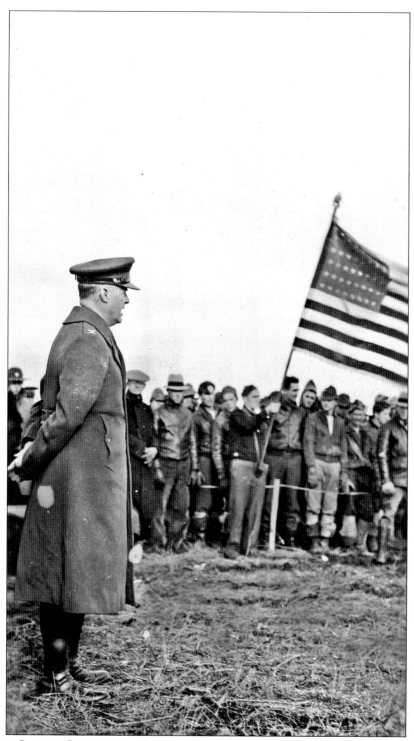

COLONEL GRANT, JULY 1937. Grant, regiment commander of the CCC, is seen here at the presentation and dismissal of the mosquito control group, with Co. 1295 standing in the background. (Courtesy of the Delaware Public Archives.)

Seven

PREPARING FOR WORLD WAR II

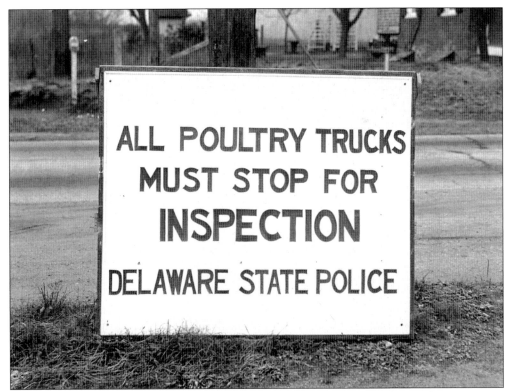

"ALL POULTRY TRUCKS MUST STOP," BY ORDER OF THE DELAWARE STATE POLICE, 1941. Poultry inspection and weighing became important toward the end of the Depression, as it looked like the state would need to enter World War II. (Courtesy of the Delaware Public Archives.)

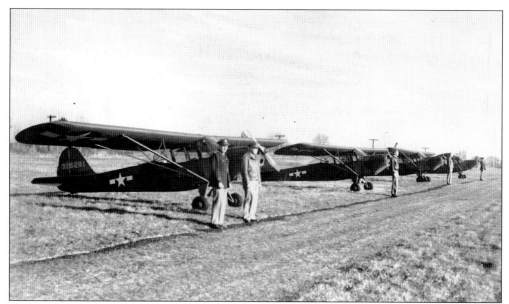

THE CIVIL AIR PATROL. The Civil Air Patrol was organized by the state at the onset of the war. They are illustrated here at the New Castle County Airfield in 1942. (Courtesy of the Delaware Public Archives.)

"CIVIL DEFENSE—OUR FIRST LINE OF PROTECTION," C. 1942. This propaganda photograph was taken early in World War II to alert the public about the necessity of civil defense, and the inclusion of a Boy Scout in the photograph highlights the concept that it was everyone's job to help protect America during the war. (Courtesy of the Delaware Public Archives.)

**THE DEFENSE
PARADE IN
WILMINGTON,
FEBRUARY 1939.**
After the rise of Nazi
and Japanese
militarism, when our
nation was
concerned that we
would be drawn into
the war, communities
across the state
organized defense
parades. (Courtesy of
the Historical
Society of Delaware.)

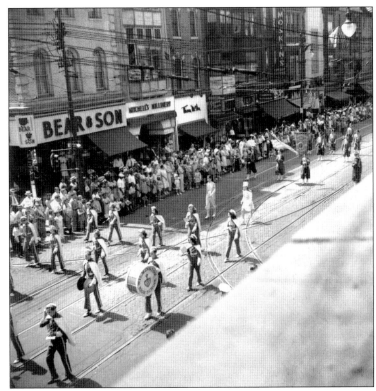

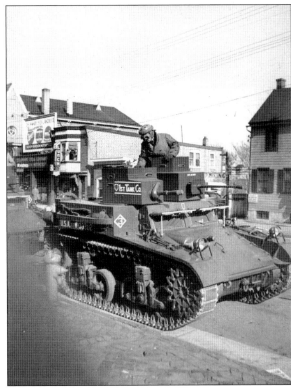

**DELAWARE FIRST TANK COMPANY,
FEBRUARY 20, 1939.** Here is a
soldier in a combat car M2A2 in
Wilmington, Delaware. (Courtesy of
the Historical Society of Delaware.)

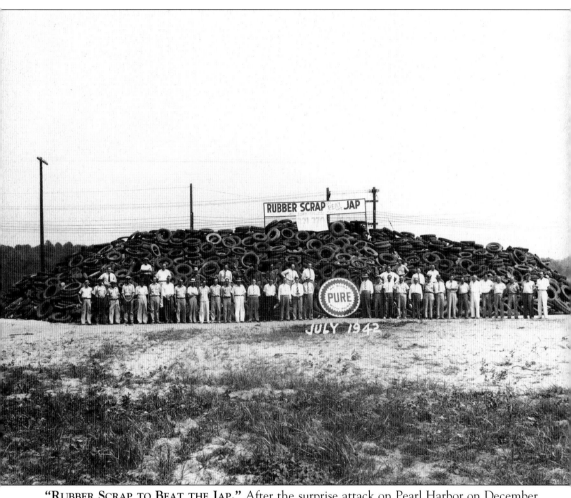

"Rubber Scrap to Beat the Jap." After the surprise attack on Pearl Harbor on December 7, 1941, Americans began a ration system and collected surplus materials to support the war effort. They began to prepare to turn the lethal engine of unrestrained warfare on two very different enemies on two fronts. To accomplish this, surplus materials were collected in bulk and used to produce wartime goods. (Courtesy of the Delaware Public Archives.)

PAPER SALVAGING, C. 1942. The war effort was a pressing need, and many Americans were terrified of the prospect of war; by giving people something to do—salvaging paper, rubber, and metal—the government provided them with a constructive outlet to calm at least some of their fears and prepare them for the fight ahead. (Courtesy of the Delaware Public Archives.)

A CLOTHING DRIVE. These efforts were to procure supplies for refugees and others suffering during wartime in Europe and Asia, as well as for the government to reuse as scrap material. (Courtesy of the Delaware Public Archives.)

COLLECTING CANNED GOODS, c. 1942. Collecting canned goods became a national hobby, and once the food inside the cans was eaten, the metal cans were reused for the war effort. (Courtesy of the Delaware Public Archives.)

SALVAGE COLLECTION, C. 1942. Salvage collection was maintained by a system of weekly pickups run by local service organizations. (Courtesy of the Delaware Public Archives.)

THE WELL CHILD CONFERENCE, DELAWARE CITY, DELAWARE, 1939. This conference was an attempt on the part of the state government to encourage women to take care of their children's health. (Courtesy of the Delaware Public Archives.)

WOMEN'S AID OF THE PENNSYLVANIA RAILROAD, c. 1942. Here, a woman sells serial novels to an enthusiastic servicemen. (Courtesy of the Delaware Public Archives.)

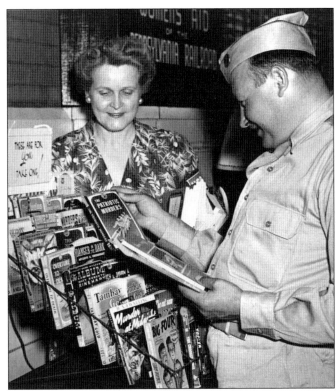

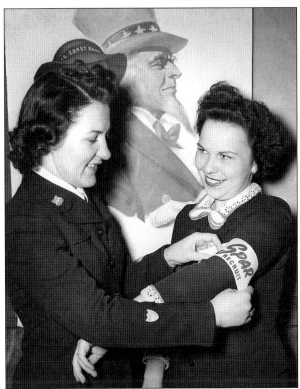

A NEW SPAR RECRUIT FROM DELAWARE. Starting in 1942, the SPARs (Semper Paratus Always Ready) served as an all-female auxiliary to the United States Coast Guard. (Courtesy of the Delaware Public Archives.)

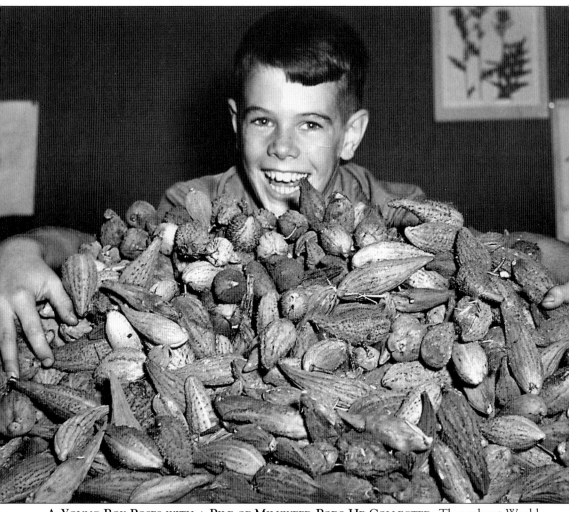

A Young Boy Poses with a Pile of Milkweed Pods He Collected. Throughout World War II, young people collected milkweed pods to provide the filling for sailors' lifejackets. (Courtesy of the Delaware Public Archives.)

Appendix I

THE CCC AND THE DEVELOPMENT OF FORESTRY DURING THE GREAT DEPRESSION

In 1898, Theodore Roosevelt created the Federal Forestry Department as a division of the Department of Agriculture. As part of his aggressive conservation agenda, he appointed nationally renowned conservationist Gifford Pinchot to head the department. By 1900, Pinchot began recruiting other like-minded individuals in each state to charter an organization called the American Forestry Association in order to bring local forestry groups together to discuss the problems each faced in developing state forestry departments and to promote the conservation of forests and wooded lands across the country. A number of philanthropic notables, including T. Coleman DuPont from Delaware, were charter members of the organization. DuPont believed in forestry and was later instrumental in the development of Delaware's forestry program.

By 1905, Pinchot released his seminal work, *A Primer of Forestry*, as a report to the secretary of agriculture. This work reads more like a desperate plea for the development of a forestry program to conserve natural resources than a government report. In it, Pinchot notes the following:

> Next to the earth itself the forest is the most useful servant of man. Not only does it sustain and regulate the streams, moderate the winds, and beautify the land, but it also supplies wood, the most widely used of all materials. Its uses are numberless, and the demands being placed upon it by mankind are also numberless. It is essential to the wellbeing of mankind that these demands be met.

Pinchot was encouraged by President Theodore Roosevelt to expand the membership and participation in the American Forestry Association and to take a more active role in the promotion of state and local forestry. In 1909, this started to make its mark on Delaware; after the urging of T. Coleman DuPont, the general assembly passed the first law related to forestry. It called for the creation of a forestry board and the need to adopt a strong conservation law.

The possibility of having state-sponsored forestry aroused little interest, and as a result, the general assembly failed to release funds that would provide for the establishment of a commission; the law remained inactive until 1921, when an act was established that gave the State Board of Agriculture the same powers as the proposed forestry board.

In 1925, $500 was appropriated to the State Board of Agriculture to begin producing a forest-planting stock. "In that same year, largely through the combined efforts of the Federation of Women's Clubs and the friends of forestry in the state," including a very powerful and prominent T. Coleman DuPont, "there was passed an act providing for the appointment of a 'Commission for the Conservation of Forests in Delaware' whose duty it was to investigate Delaware forest conditions, paying special attention to holly trees and to make a report together with such recommendations as they might deem necessary."

Again, no funds were released for the commission to put the recommended actions into effect until T. Coleman and Francis V. DuPont donated the amount to conduct the necessary study. William S. Taber—a young forester and distant cousin of the DuPont family and a relative of Izette DeForest-Taber of the DeForest/DuPont family—was apparently working with Coleman in some capacity.

Taber was the natural choice to draft the study for the commission. In 1927, the report was presented to the state legislature; it was adopted, and the Forestry Commission was created, but not without some loss. His first and most urgent task was to have legislation passed that would enable the forestry department to act on behalf of the citizens of Delaware in protecting land. Naturally, opposition arose, and the bill was defeated by a nine-to-seven vote in the state senate. A modified version of the bill, "without teeth," was later passed. The legislators were reluctant to give the state forester the power of eminent domain, to provide for the condemnation of lands when forestry interests were at stake, and to draft men from all surrounding areas to fight forest fires. After these exceptions were addressed, the State Forestry Commission was formally established, and members were chosen to represent each county.

On Thursday, August 25, 1927, in the office of Gov. Robert P. Robinson, the State Forestry Department was created by act of the Forestry Commission.

This task over, the commission now turned their attention to employing a state forester. William S. Taber was, again, the natural choice. Taber was working with DuPont in Cambridge, and though there is no record describing whether he worked on DuPont land in Cambridge, Maryland, or worked in Cambridge, Massachusetts, at Harvard, given his familial connections the former seems most likely. What is certain is that the initial offer of the forestry commission granting a $2,000 salary proved unacceptable. In his letter rejecting the offer, Taber noted the following:

> Realizing fully the handicaps under which the Commission is working and thoroughly appreciating the honor they confer upon me in offering me the position as full time State Forester, for personal financial reasons I find it necessary to reject the offer as it now stands. . . . Realizing the commission's obligation to Mr. DuPont and conceding the position it takes on a point of ethics as being absolutely sound and practical; I would accept the position if . . . the Commission sees fit to provide in its offer to me a stipulation that after a certain period of time has elapsed the salary specified will be increased shortly to $3,600 and then $4,000.
>
> I believe that the commission should have no fear that such action as they may take will have any effect on the attitude of either Mr. Coleman DuPont or Mr. F.V. DuPont. I have talked the matter over candidly with both and they have each been equally as frank with me.

The Forestry Commission agreed to these terms, and at their second meeting on September 29, 1927, William Taber was appointed as the first state forester of Delaware. This was the position he would occupy for the next 44 years.

The political work of establishing a forestry department done, the real struggle of developing forestry just began. First, the pragmatic problem of acquiring a forest arose. For the first year of Taber's employment, the state government did not know what to do with him; he did everything from making sure the trees on the Green were healthy to monitoring the rainfall. The lack of a forest to manage was a severe handicap to meaningful, productive work.

In 1928, Coleman DuPont donated the first tract of forest land to the State of Delaware for reforestation and experimental planting. The Appenzeller Tract, as it was known, sat along the newly completed DuPont Highway between Georgetown and Ellendale in Sussex County. It was at this tract that Taber started experimental planting of loblolly pine, Douglass fir, red pine, Norway spruce, white pine, short-leaf pine, black walnut, southern cypress, tulip trees, magnolia, Japanese black pine, black locust, and red oak. These trees were measured and tested for their feasibility as crops. It was here that Taber also started experimenting with soil and the concept of putting idle agricultural lands to use as forests.

To some of Taber's most ardent critics, forestry and conservation seemed to be a radical deviation from standard land use practices in Delaware. In an environment made up mostly of swamps and sandy loam, the standard practice was to drain and fertilize, rather then plant young trees. But Taber, in his first report, made it very clear why forestry was necessary:

> The essential reason for reforestation is a solution, at least in part of the economic use of land. In the last decade Agricultural practice everywhere in [the] Continental United States has undergone rapid changes. Part of this change has been the result of previous over-stimulated and misdirected agricultural expansion under which crop land was brought into use without due consideration begin given to the physical character and productivity of the land. And public land policy attempting to curtail this expansion would not have met with tremendous opposition but the problem of maintaining this over expansion is one of the Nation's greatest difficulties.
>
> Further reduction in the per capita amount of land required for the production of agricultural crops has been brought about by the substitution of mechanical for animal power and by various improvements in the methods of economically producing crops. The competition between good lands and poor lands under such economic conditions has forced the abandonment of the poorer lands. These abandoned lands have become a tax burden, which must be carried by the productive lands.

Forestry, he argued, saved money in the long run when it put lands to good use that were too wet and sandy in Sussex, or when it put to good use hillsides in New Castle that were likely to erode if traditional plant crops were produced. He reasoned that these areas could easily accommodate forestry. Once the trees were in place, the key to success would be managing and fighting forest fires, though, at least initially, forest fires were given a secondary role to more pressing fiduciary needs.

This changed in 1930 when Delaware experienced the worst forest fire in recorded history. That year, for unknown reasons, the Great Cypress Swamp between Gumboro and Selbyville on Route 54—Delaware's largest natural forested area—caught on fire. The fire burned for days in a violent fury that consumed over 30,000 acres and approximately 20 miles of forested swampland. This event started the campaign to hire forest wardens to report forest fire activity and develop fire towers that would cover the state.

Despite the need to protect the land from fires, at the onset of the Great Depression between the years 1931 and 1933, the forestry department was consistently understaffed. The forester's reports for these three years noted that much needed work was neglected and that he could not support the staff he had. In 1933, Governor Buck dissolved the state legislature during a heated

discussion concerning the equitable distribution of funds, and subsequently he lowered the salary of all state employees—including Taber—by half.

At least the program setbacks were not long lasting, and by August 4, 1934, the forestry department acquired 1,133 acres from the administrators of the Harry W. Jester estate. In a deal that must have seemed particularly piquant at the height of the Depression, $8,800 was paid to the Milford Trust Company to pay off Jester's debts and $8,800 was paid to Harry W. Jester Jr. The Forestry Department proceeded to name the plot of land after local Civil War hero Col. William O. Redden, and the small community adjacent to the property along DuPont Highway they called Redden (formerly Carey).

In commemoration, this plot of land was called the Jester Tract of the Redden State Forest. On August 30, 1934, Taber, seeing the work that the CCC was doing in other parts of the country, requested a CCC company to assist in the management and reforestation of the Jester Tract. By September 1, the request was granted, and construction plans for a camp were started on September 4. By September 18, the work was underway. On October 6, Emergency Conservation work personnel, United States Forestry Department personnel, and personnel from the United States Army arrived and started working on a variety of forestry projects.

Lt. Robert A. Gaw, a member of the infantry reserves of the CCC stationed in Slaughter Beach, was made the officer in charge of construction, and Ralph Poytner of Rehoboth was made the superintendent of construction. Within two months, the camp had 14 buildings.

On the evening of October 10, 1934, the 185 men of CCC Company 2210 Montpelier, Vermont, boarded a train at the station just outside of Montpelier and started the journey south to Delaware. They arrived at the Georgetown train station at 8:30 in the morning on October 11. Thayer Royal, of Holden, Massachusetts, was the first lieutenant in charge of the company. On arriving, and with considerable assistance from Colonel Corkran, the CCC superintendent for Delaware, Lieutenant Royal was provided with eight 22-ton trucks to transport his men to the camp. That January, this troop of veterans from Vermont was supplemented by CCC Junior Company 1293, transferred from Fort Dix, New Jersey.

That same year, Taber began pushing the envelope of forestry's responsibilities; he introduced the concept of recreation into forestry with his impassioned "plea for state forests and forest parks." In his 1934 report, he noted the following:

> In most other things of public benefit and advancement, Delaware is generally found among the leaders if not actually ahead of its neighbors, but in the conservation of natural resources, particularly that of forests, it compares unfavorably with states far less blessed in wealth, resources, climate and terrain.
>
> Primarily the reason for this situation is that few citizens of the state are park or forest conscious and those few are of such minority that their pleadings fall on too many deaf ears.
>
> The efforts of the Department in encouraging the state to provide for the acquisition of areas to be used as state parks, state forests, and recreational areas lacks the public initiative that is much needed to put it across. In many of the neighboring states much forest and park land has come into public ownership through gratuitous deeds, but recently related data reveals that Delaware is at the bottom of the list not only in acreage of state forests but in the same position so far as contributions are concerned.
>
> There is a real need for such publicly owned or controlled land in the state. Granting that the need may seem at present idealistic; granting that it leans heavily on the aesthetic; and granting that it is even a selfish point of view of the forest enthusiast, the fact remains that less than 1% of the general funds of the state are made [available] for forest conservation.
>
> Our citizens are finding more spare time on their hands than they can use at home. Given suitable outdoor recreational places, they will use them and appreciate them. If they are able to be had near home, it is logical to expect that many of them [will not take] their vacations in other states where the advance step has been taken.

In August 1934, the state legislature passed a bill that provided the Forestry Department with $50,000 for land acquisition so Taber could develop public camping grounds, but Governor Buck vetoed the bill.

This shift away from the older argument that conservation should be practiced solely for economic reasons was a change in the fundamental approach that Taber introduced to the fledgling Forestry Department. Land should no longer be preserved for the singular economic benefit that can be derived from it. Rather, it should be preserved because there are people who will want to enjoy it. Taber's 1934 report marked the first time that recreation, as a concept, was given a voice within state government. Taber argued that conservation and recreation were the two central roles of forestry, and this point marked a significant change in how Delawareans approached conservation.

These two roles have marked the identity of the Forestry Department ever since. Taber argued that, in its conservation role, forestry had the power to ebb the flow of soil erosion and put unproductive land back into productive use, while recreation would allow others to experience and learn about the conservation of natural resources. In each forester's report after 1934, these two roles were clearly linked.

That same year the CCC camp at Redden was appropriated $200,000, and it was agreed that Taber would be the director of the area. In this way, Taber let the federal government develop recreational opportunities, while focusing on the conservation and economic role of forestry for the state government.

By 1935, the money reached Redden, and that fall, recreational improvements were started. The CCC workmen "improved the roadside picnic area in the Ellendale Forest . . . " while "on the Redden area immediately south of the Redden-Bridgeville Road and overlooking the Gravelly Branch, tributary of the Nanticoke River; a picnic development is underway. The east bank of the stream adjacent to the bridge has been cribbed and filled. When the fill settles, two picnic tables will be erected on site. Further back, a covered picnic shelter with [a] stone fireplace is almost completed. Plans for a parking area, latrines and tables to be constructed later this year." Each of the buildings at the site was finished by 1937, and they were all "constructed from logs salvaged from storm damaged trees."

Taber and the State Forestry Commission had been seeking land near the Appenzeller Tract since at least 1928, and the Gun Club property owned by Richard and Marie Haughton from Philadelphia was one of the areas on which Taber focused his attention.

On December 21, 1936, after prolonged negotiations, the State Forestry Commission purchased the 744-acre Gun Club tract. In his press release of the event, Taber noted the following:

> Title to the well known Gun Club property, consisting of about 720 [actually 744] acres of woodland and farms, situated east of Redden Station about three miles north of Georgetown, and formerly belonging to Mr. Richard Haughton of Philadelphia; was accepted here today by Mr. George S. Williams, Chairman of the State Forestry Commission. . . .
>
> Under management of the State Forestry Department, it will become a unit of the Redden State Forest and be improved for timber production, outdoor recreation and wildlife conservation. Most of the improvements will be preformed by CCC workmen from the Redden State Forest Camp. Immediate plans call for the completion of roads and truck trails now under construction to provide accessibility for administration, management protection and future public use.

From January through March 1936, CCC Camp S-53 Company 1293 built three structures at the Gun Club tract, demolished two others, and worked on creating fire breaks and expanding ditches to prevent the spread of forest fires.

During 1937, the CCC programs at Redden continued making improvements; roads were made more accessible, reforestation progressed in earnest, and one land acquisition was recorded. In July 1937, the forest acquired 136 acres from the estate of Oliver Jones for $410.

During 1938, improvement projects continued, and additional work was completed. By 1938, it had become obvious to many that changes at home and abroad were making it very difficult to justify continuing the CCC's program. The economy had improved markedly from its low in 1932, and the number of industrial manufacturing jobs steadily increased in direct proportion to aggression throughout the world.

The beginning of 1939 was promising; the Gun Club tract had expanded, and other portions of the forest were growing. That June started off with the acquisition of a large tract from the Short estate, and progress was being made daily on creating an operational system of fire breaks to prevent the spread of forest fires in Redden. These improvements hid the fact that CCC Camp S-53 would close at the end of the month.

On Monday morning, June 30, 1939, the CCC's program at Redden State Forest officially ended, and Camp S-53 closed. Though Taber knew that the camp would close if the general assembly did not continue to increase funding to match the federal priorities, that prospect had always seemed unlikely. William Taber was at a loss when he noted the following in his final report from this period:

> Failure of the Department to have sufficient funds and accompanying technical personnel to carry out [the] increased burden and thereby benefit to the fullest extent from these Federal projects exposes the State's Forestry program not only to nullification of much that has been accomplished, but to encroachment and ultimate submersion by Federal projects backed by ample funds and personnel. Preservation of State sovereignty and the jurisdiction of public matters assigned to the State Forestry agency would therefore appear to lie in strengthening the Department so that it could keep pace with, if not supercede, the ever increasing Federal forestry projects.

Unfortunately for Taber, the general assembly would not consider this and could not grasp his vision. Later in the report, Taber notes the following:

> On the last day of the fiscal year CCCs Camp S-53, situated on the Redden State Forest, was closed in pursuance to an order dated May 22, issued by Robert Fechner, Director, CCC. The reason for closing the camp was given in the orders " . . . the recent failure of Delaware's state legislature to meet the requirements of the CCC Act of June 28, 1937 with respect to making adequate provision for the use and maintenance of CCC accomplishments. . . ." The CCC director was informed that the Department was prepared to assume maintenance of CCC work preformed on the State Forest and that it would be unfair to penalize the Department for responsibilities not of its participation.

After an unsuccessful meeting with the governor, Delaware's congressional delegation, and leaders of the CCC, Taber noted the following with regret:

> The end of fiscal year 1938 marks five years of CCC activity in the United States and 3 years 9 months of Federal cooperation with the State Forestry Department in CCC forestry projects. Prior to the inauguration of this method of unemployment relief, Delaware had practically no State Forests. It now has 2,583 acres of such forests acquired under the direction of the State Forestry Commission and improved for timber production and recreation by CCC personnel of Camp S-53 under the supervision of the Department and the Commission. Thus, the CCC has not only been the agency which gave impetus to the

long dormant forest land acquisition program of the Department, but has also been the means of effecting dreamed of improvements to such state land and nearby private forest lands as will result in values far in excess of the capital outlay made by the Department and the State.

Robert Fechner reassigned the men of the CCC Camp S-53 to their home post at Fort Dix.

With the end of this era, William Taber, while disappointed, remained the state forester and continued to expand the forest during 1940. On August 27, 1940, the Forestry Commission added a tract from the estate of the Pase family, and in November it added the Carey property for $600. This was the last recorded purchase of forestry property for the next 11 years.

After December 1941 and the beginning of World War II, the conservation movement and the reformist vigor of the previous decades was grimly overshadowed by the specter of war. At Redden, Taber and his staff did their best to promote conservation to help the war effort. This included letting the Air Corps use the fire towers for defensive purposes. It was another 38 years before the state's Forestry Department made another major land purchase and the conservation of forests became a priority again.

In their short tenure in Delaware from roughly 1934 until 1938, the CCC drained more marshlands for agricultural use then had previously been done in a little over 200 years. In addition, the CCC developed the first state forests in Redden and Blackbird, promoted the conservation of trees, conducted the first biological surveys in the state's history, and built fire towers stretching from the Cypress Swamp in the south and west to the Maryland border and on the edge of every major tree stand in the state. Their controversial use of DDT did help rid the marshes of mosquitoes but also had unintended environmental consequences that they could not predict at the time. In Sussex County, the CCC developed Trap Pond State Park and the Assawoman Wildlife Refuge; built roads, recreation areas, dams, and bridges; and ditched flood-prone areas. They built the sand dunes at Lewes Beach and prevented the erosion of Delaware's beaches. After their incorporation into the U.S. Army, the same men who had accomplished all this assisted with the construction of gun placements and the construction of military and coastal defense towers from Fort Miles to Fort Salisbury.